IMAGES
of America

THE JEWISH
COMMUNITY *of*
NEW ORLEANS

On the cover: This is the only known photograph of the altar of old Temple Sinai on Carondelet Street, taken just a few years before the building of the new temple in 1928. The scene is a costume event, but it is not know whether it is Purim or Mardi Gras, either of which is possible in New Orleans's most classically Reform Jewish congregation.

IMAGES
of America

THE JEWISH COMMUNITY of NEW ORLEANS

Irwin Lachoff and Catherine C. Kahn

Copyright © 2005 by Irwin Lachoff and Catherine C. Kahn
ISBN 0-7385-1835-2

Published by Arcadia Publishing
Charleston SC, Chicago IL, Portsmouth NH, San Francisco CA

Printed in Great Britain

Library of Congress Catalog Card Number: 2005925412

For all general information contact Arcadia Publishing at:
Telephone 843-853-2070
Fax 843-853-0044
E-mail sales@arcadiapublishing.com
For customer service and orders:
Toll-Free 1-888-313-2665

Visit us on the internet at http://www.arcadiapublishing.com

CONTENTS

ACKNOWLEDGMENTS

The authors wish to acknowledge the invaluable assistance of Eve Godchaux Hirsch and Vicki Lazarus, volunteers in the Touro Archives, for research and proofreading, and Lester Sullivan, Xavier University Archivist, for his guidance and encouragement. We also wish to recognize Dan Alexander for his historic knowledge of Congregation Gates of Prayer; the research division of the Historic New Orleans Collection, who were always most helpful; Marc Rubenstein, Executive Director of Touro Synagogue; Herbert Barton, Executive Director Emeritus of Temple Sinai; Louis Geiger, Temple Administrator of Congregation Gates of Prayer; and all the companies and individuals who donated their time and photographs toward the completion of this book. Finally, we especially wish to thank Fred Reed, Library Systems Technician at Xavier University Library, without whose invaluable technical assistance this book could not have been completed.

The authors wish to credit the following for permitting use of photographs: The American Jewish Historical Society, Sydney Besthoff III, Robert Cahn, Congregation Anshe Sfard, Congregation Beth Israel, Congregation Gates of Prayer, Margaret Blum Epstein, Brad Fanta, Joseph E. Friend, William Goldring, the Hermann-Grima House Museum, the Historic New Orleans Collection, Maunsel White Hickey, Abigail Kursheedt Hoffman, Isidore Newman School, Roger B. Jacobs, the Jewish Community Center of New Orleans, Charles N. Kahn Jr., Hugo Kahn, the Kohlmeyer family, Celia Seiferth Kornfeld, Thomas B. Lemann, Longue Vue House and Garden, the Louisiana Division of the New Orleans Public Library, Jane K. Lowentritt, Leta Weiss Marks, Albert Mintz, Claire Hyman Moses, Sidney Pulitzer, J. William Rosenthal, M.D., Shir Chadash Conservative Congregation, Arthur Silverman, Stephen Sontheimer, the Southern Jewish Historical Society journal, the Southeastern Architectural Archive at Tulane University, Lester Sullivan, Temple Sinai, Touro Infirmary Archives, Touro Synagogue, Tulane University Special Collections, Liselotte Weil, and Xavier University of Louisiana Archives and Special Collections.

INTRODUCTION

New Orleans is fast approaching the 250th anniversary of the arrival to the city of its first permanent Jewish settler. Isaac Monsanto, a Dutch Sephardic Jew from Amsterdam, came to New Orleans from Curacao in 1757, and over the next few years, three brothers and three sisters followed. In late 1769, the Monsantos were expelled by Don Alejandro O'Reilly, the Spanish governor, specifically because they were Jewish. The original *Code Noir*, or Black Code, published by the French crown in 1724, expelled all Jews from Louisiana but had never been invoked by the French. The family immigrated to Pensacola and was allowed to return to New Orleans within the year. They returned, and descendants of two of the sisters, Angelica and Eleanora, still live in New Orleans today.

Jewish pioneering to New Orleans did not begin in earnest until the purchase of Louisiana by the United States from France in 1803. These men came seeking fortunes, with no interest in practicing their religion. The two Judahs, Touro and Benjamin; Samuel Hermann; and Samuel and Carl Kohn all found tremendous success in their varying endeavors, and all, save one, had no connection to the local Jewish community as it began to create religious institutions.

The first congregation in the city, Shangarai Chasset, or Gates of Mercy, was founded in 1827. Jacob Solis, a New York merchant in town on an extended business trip, attempted to buy matzo to celebrate the Passover. Unable to find any matzo for sale, he bought some meal and ground his own. Enraged and inspired, he decided to organize a congregation, and by Rosh Hashanah, services were being held. The constitution, written by the Sephardic Solis, proclaimed that the congregation would follow the Sephardic *minhag*, or ritual, even though two-thirds of the 33 charter members were either German or Alsatian and followers of the Ashkenazi ritual. The constitution made concessions to the reality of early New Orleans Judaism, allowing the "strange," or Gentile, wives of the members to be buried in the congregational cemetery, and also allowing the children of these "strange" women to be consider members of the congregation and, therefore, Jewish.

In 1842, as more and more Alsatians and Germans joined the congregation, the ritual was changed from the Sephardic to the Ashkenazi. Three years later, following the leadership of the first religious Jew to live in the city, Gershom Kursheedt, a new Sephardic congregation was formed. Kursheedt named the new congregation Nefutshoh Yehudah, or Dispersed of Judah, in honor of Judah Touro, in the hope that Touro would assist them.

Meanwhile, even more Alsatians were settling just upriver, in the suburb of Lafayette City, today generally the Garden District of New Orleans. They formed a congregation in 1850 and named it Shaare Tefillah, or Gates of Prayer. Primarily small shop owners or river workers, the congregation sought to join with the more socially established and affluent Germans and Alsatians at Gates of Mercy, but their entreaties went unheeded.

In 1870, Temple Sinai, the only congregation in the city originally chartered as Reform, was formed, and almost immediately became the largest, wealthiest, and most socially prominent congregation in the city. Within two years, the congregation built a magnificent temple—a city landmark—just off Tivoli Circle (now Lee Circle), proudly displaying the confidence and security the members felt in the city and publicly proclaiming their religious beliefs.

During the 1870s, the original congregations suffered. Over half of the members of Gates of Mercy left to join Sinai. Then, in 1878, a particularly severe yellow-fever epidemic hit the congregation hard. Dispersed of Judah suffered the same fate as many of the Sephardic congregations around the country; many members married out of the faith and left the religion. In 1881, the two congregations agreed to consolidate. The congregation was now named "The Gates of Mercy of the Dispersed of Judah," a somewhat awkward name, and Rabbi Leucht soon began referring to the congregation as "Touro Synagogue," in honor of their patron.

East European Jews began arriving as early as the 1850s, and in 1858 Congregation Tememe Derech, or The Right Way, was established. The congregation followed the Polish version of the Ashkenazi ritual and was known as "The Polish Congregation." Other congregations followed, structured along nationalistic lines: the Galitzeaner congregation Chevra Thilum, the Litvak congregation Chevra Mikve Israel, and the Lithuanian Chasidic congregation Anshe Sfard. All were small; none had more than 50 members, and all were located in the "Dryades Street neighborhood," the Orthodox neighborhood of the city for over 50 years. Only Tememe Derech had a synagogue; the rest met either in rented quarters or members' homes. And they were, and remain today, the clear minority of Jews in the city.

In the first decades of the 20th century, the congregations began to move further uptown, following the migration of their members. The first to move was Touro Synagogue, in 1909, from Carondelet Street to Saint Charles Avenue. Chevra Thilim built its synagogue on Lafayette Street in the old Dryades Street area in 1915. Moving in the 1920s were Anshe Sfard, Gates of Prayer, and Temple Sinai, while Beth Israel built a new sanctuary at the same location on Carondelet Street in 1924.

In 1955, the members of Chevra Thilim voted to allow mixed seating while remaining an Orthodox congregation. Those that did not want the mixed seating sued. Eventually the case made its way to the Louisiana Supreme Court, which ruled that if the congregation were to remain Orthodox, there could be no mixed seating. As a result of this ruling, the Conservation Congregation of New Orleans was founded in 1958. In 1976, the congregation changed the name to Tikvat Shalom, or Hope of Peace. Two years later Tikvat moved to the suburb of Metairie, where the majority of New Orleans Jews now live, and the congregation has very much prospered. Three year earlier, Gates of Prayer had been the first to move to Metairie, and they, too, are growing. Meanwhile, Chevra Thilim remained uptown and continued to lose members. The congregation decided to allow mixed seating in hopes of stemming the tide. But members continued to leave, and in 2001, Chevra Thilim merged with the Metairie congregation, Tikvat Shalom, and changed the name of the merged congregation to Shir Chadash, or New Song.

Jewish service organizations thrive. The Jewish Federation of New Orleans provides valuable services to all aspects of the local community. The local Hadassah chapter has an active membership. Indeed, it is through institutions such as the National Council of Jewish Women, B'nai Brith, the Jewish Endowment, the Jewish War Veterans, Jewish Children's Regional Services, and two Jewish community centers that most of the Jews of New Orleans act out their Jewishness.

One

PIONEERS

La Code Noir, or the Black Code, of 1724 was promulgated by the French crown to establish "what concerns the state and condition of the slaves" in the Louisiana territory. However, the first article proclaimed that "all Jews who may have established their religion there be expelled within three months under penalty of confiscation of body and property." This restriction was never enforced during French colonial rule.

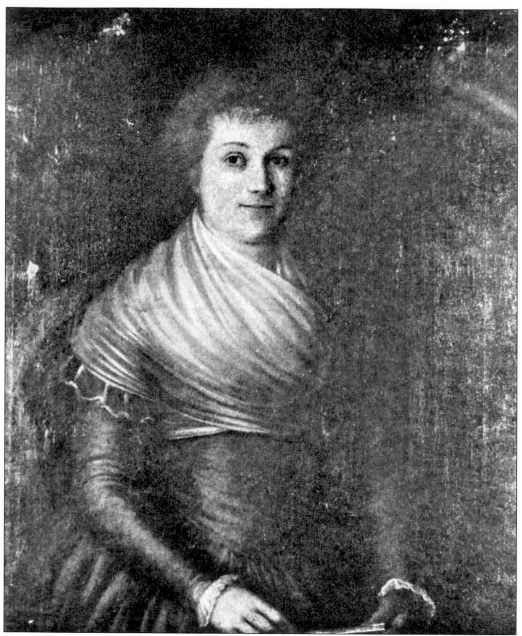

Shown here is Angelica Monsanto Dow (1744?–1821). This is the only portrait of a member of the first Jewish family to permanently settle in New Orleans. Her brother, Isaac, arrived in 1757, and over the next few years three brothers and three sisters, including Angelica, joined him. In 1769, the family was expelled and their property confiscated by the Spanish, Governor O'Reilly citing the *Code Noir*—which prohibited Jews in Louisiana—as the reason for expulsion. The family moved to Pensacola, where Angelica married a Scottish Protestant, George Urquhart, and became a devout Protestant. The Urquharts eventually returned to New Orleans and became prominent members of New Orleans society. Their eldest son, Thomas, was a member of the Louisiana House of Representatives and an officer of the United States Bank in New Orleans. After Urquhart's early death, Angelica married another Scottish Protestant, Dr. Robert Dow.

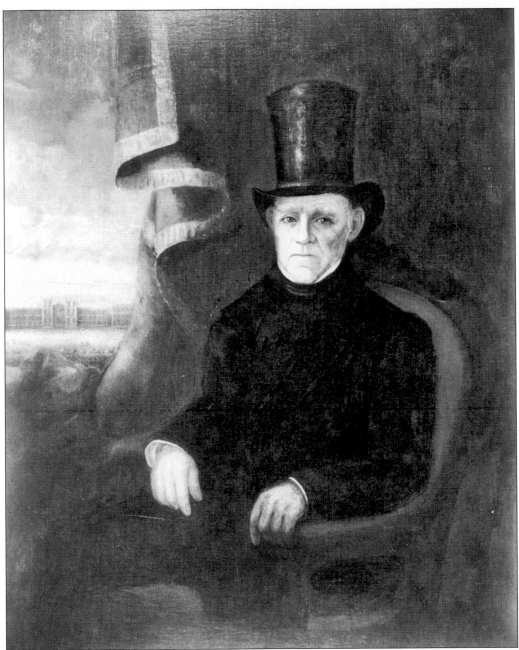

Judah Touro (1775–1854) was the son of Isaac Touro, the hazan, or minister-cantor, of Congregation Yeshuat Yisroal in Newport, Rhode Island. After his father's death in Jamaica in 1783, young Judah, along with his mother, brother, and sister, moved to Boston where, at the age of eight, he became an apprentice to his mother's brother, Moses Michael Hays, a successful businessman. In 1802, Touro abruptly left Boston, eventually making his way to New Orleans, where he slowly but surely made his fortune as a commission merchant and in real estate, owning much of what is today the downtown section of the city. After suffering a near fatal injury in 1815 at the Battle of New Orleans, he was a virtual recluse the last 40 years of his life. His will left money to almost every Jewish organization in the United States, as well as an almshouse in Jerusalem.

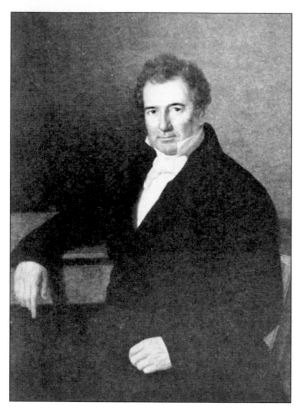

Samuel Hermann (*c.* 1777–1853) was born in Roedelheim, Germany. He arrived in Louisiana around 1805, settling just along the German Coast in Saint John Parish. In 1806, he married a Catholic widow, Marie Emeronthe, with whom he had three sons and a daughter. By 1813, he was in the city, acting as a merchandise agent and personal banker with financial interests throughout the United States and Europe.

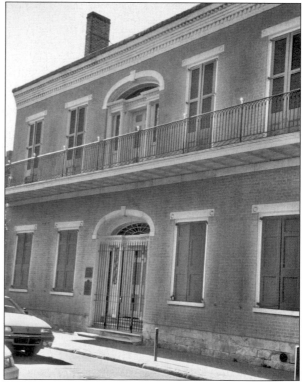

In 1823, Samuel Hermann bought the home at 820 St. Louis Street. Eight years later, he tore down the existing property and built one of the showpiece homes of the city, renowned for the grand soirees that occurred there. Financial difficulties forced him to sell the home in 1841. Eventually the house was bought by the notary Felix Grima. Today the home is a museum, the Hermann-Grima House.

Samuel Kohn (1783–1853) was born in the village of Hareth, Bohemia, and wasted his youth drinking and gambling. One day he lost so much money gambling that he was too embarrassed to go home and explain to his parents. He left, telling no one, and finally made his way to New Orleans some time around 1806. He opened an inn on Bayou St. John, offering drinking, gambling, and loans to partake in the games. Soon he opened a bank and became a leading real-estate developer. He retired to Paris in 1832.

Carl Kohn (1815?–1895) was brought to New Orleans by his uncle Samuel in the early 1830s. Without any formal education, he quickly taught himself English, French, and Spanish. Through his uncle he gained access into the finest society, and in 1850 he married Clara White, daughter of Maunsel White, the wealthiest man in the city. Among Kohn's many business enterprises were the Atlantic Insurance Company and the Union National Bank. He died in 1895, "one of New Orleans' most respected citizens."

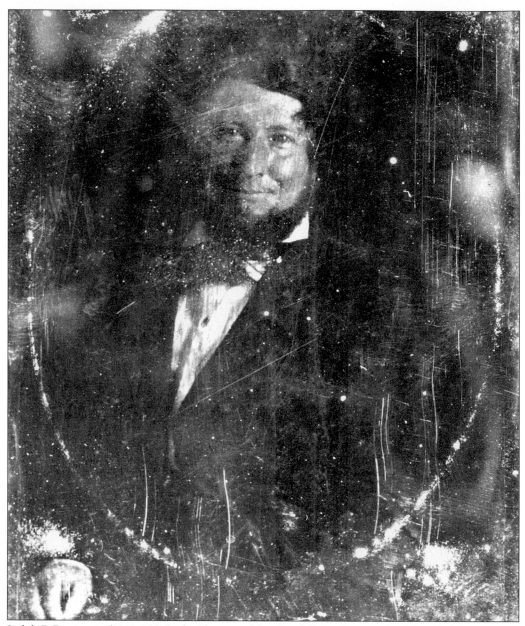

Judah P. Benjamin (1811–1884), the "brains of the Confederacy," arrived in New Orleans in 1827 and began reading the law in preparation for becoming an attorney. After a successful 10 years in practice, Benjamin began a sugar plantation just below the city, which he named "Bellechasse." He was elected to the United States Senate in 1852, the first avowed Jew elected to that body. He was nominated for a seat on the United States Supreme Court the following year, but he turned the nomination down, preferring the hustle and bustle of the legislative body. In the Senate, his was a leading voice in the cause of Southern rights, and he proudly joined the Confederate Cabinet. As the war ended, he made a harrowing escape to London, where he once again took up the law. He never returned to the United States. He died in Paris in 1884, his wife having had a priest administer the Catholic last rites. The above image is a heretofore unpublished daguerreotype of Benjamin taken sometime in the 1850s.

A native of Belfort, Alsace, Abel Dreyfous (1815–1891) left France about 1834, arriving first in New York City. There he heard about New Orleans, a city where French was spoken in the streets, and where the Civil Code, which was used in France, rather than Common Law, used in the rest of the United States, was the law of the land. For a lad who had studied to be a notary, New Orleans was the promised land. He survived first by making and selling soap, while clerking in the notarial firm of Cuvillier. After gaining his notarial commission, he became a partner with Cuvillier. The notarial acts of Abel Dreyfous form a significant body of work in the Notarial Archives of Louisiana. He was the most important Jewish notary of 19th-century New Orleans.

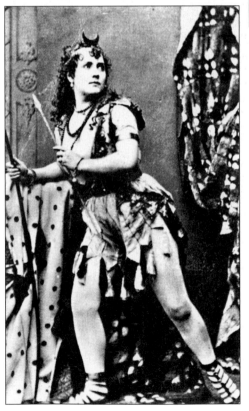

Adah Isaacs Menken (1835–1868) was born to a French Creole actress. As a child, she danced in the ballet at the French Opera House and wrote poetry. She took up the stage and married the Jewish orchestra leader Alexander Isaacs Menken. While not together long, she did adopt his Judaism and practiced it the rest of her life. As an actress, she was notorious for appearing in the play *Mazeppa*, in which she would ride off stage on horseback dressed only in skin-colored tights that made her appear nude.

Hermann Kohlmeyer (1814–1883), a brilliant Jewish scholar and linguist, was recommended by Rabbi Isaac Meyer Wise to serve on the proposed beth din that was to examine Wise's prayer book, Minhag America. Occasionally he served as a temporary minister at both Gates of Mercy and Dispersed of Judah, but eventually he gave up the ministry for a career in education, becoming professor of Hebrew and Oriental literature at the University of Louisiana, now Tulane University. As Rabbi Max Heller later wrote, his "shrinking modesty and his retiring habits probably unfitted him for the responsibilities of the religious leader."

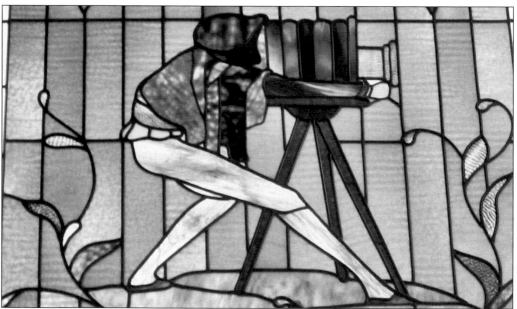

Samuel Moses (1798–1885) learned the art of camera obscura from Daguerre, its inventor, in Paris. When he came to New Orleans in the 1830s to work as a chemist in the sugar industry, he brought his photography equipment with him. He taught his sons Bernard (1832–1899) and Gustave (1836–1915) the techniques he had learned, which they employed professionally, first at Camp Street on the corner of Gravier, and later at Camp and Canal. At the end of the Civil War, Gustave photographed soldiers in their uniforms, at 25¢ a picture, as they were being mustered out. With the proceeds, he started G. Moses, later G. Moses and Sons, which was in business from 1866 to the 1930s. A stained-glass sign of a photographer with his head under a hood was displayed outside another studio location, now Preservation Hall, on Saint Peter Street.

Shown here is the title page of the 1828 constitution of Congregation Shanarai Chasset, or Gates of Mercy. On the day before Passover in 1827, Jacob Solis, a New York merchant in New Orleans on business, went in search of matzoh to properly celebrate the holiday. Unable to find any for sale, he bought some meal and ground his own. Enraged by the lack of any Jewish communal life, he started a congregation. As only three of the 33 charter members of the new congregation were married to Jewish women, the constitution that Solis wrote made certain exceptions to the reality of New Orleans Judaism. It allowed that these "strange"—that is, Gentile— spouses could be buried in the congregational cemetery. Also contrary to Jewish law, the constitution allowed the children of these Gentile spouses to be considered members of the congregation and, therefore, Jewish. Solis left New Orleans for home after six months, promising to return with a Torah and prayer books, but he died in New York before his return, leaving the congregation without knowledgeable religious leadership.

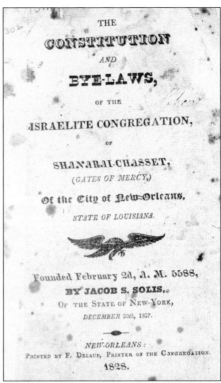

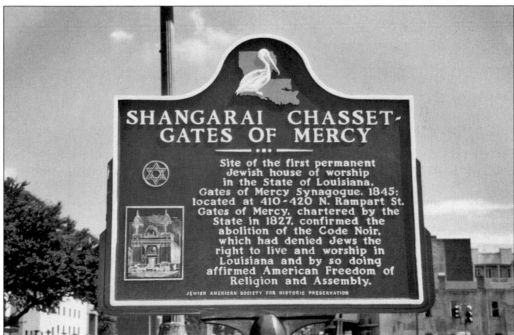

This plaque commemorates the first congregation in Louisiana, Gates of Mercy. The building the congregation moved into in 1843, which was to be their synagogue, was the first building owned by a Jewish congregation. It was in terrible disrepair, so donations were solicited, the building torn down, and a new one dedicated in 1851.

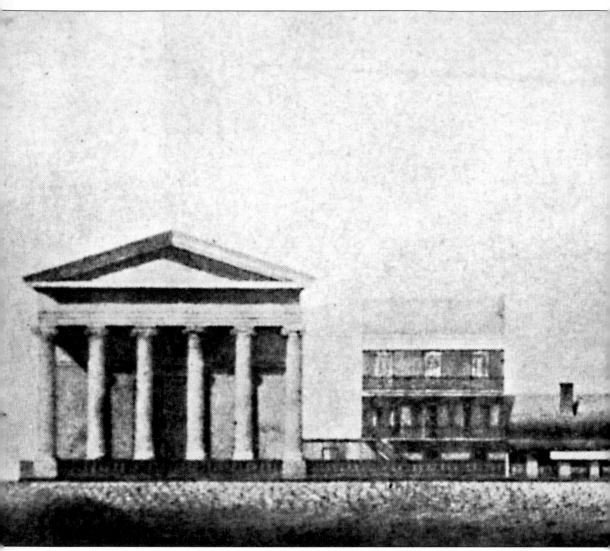

The first building dedicated as a synagogue was on the corner of Canal and Bourbon Streets. Nefutzoh Yehudah, or Dispersed of Judah, founded in 1845, was named by Gershom Kursheedt to honor Judah Touro in hope of inspiring Touro's largesse. Kursheedt's plan worked, for two years later Touro gave the Sephardic congregation this property that he owned, Christ Church. The building was small and the church members wanted to build a larger edifice. Touro, who owned a pew in Christ Church, swapped this property with a vacant lot he owned two blocks down Canal

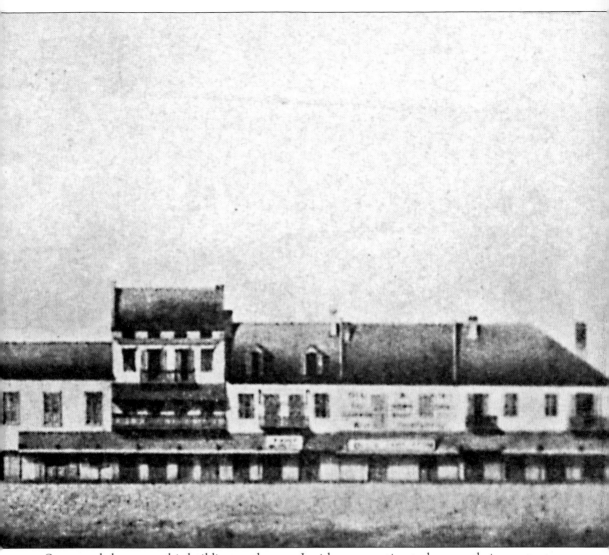

Street and then gave this building to the new Jewish congregation to become their sanctuary. Renovations took three years, mostly due to Touro's interference, but the synagogue was finally dedicated May 14, 1850. There were two dedications: one in the morning for just a few invited guests, bowing to the wishes of the reclusive Touro, and a grand dedication that afternoon with the entire city invited to the festivities.

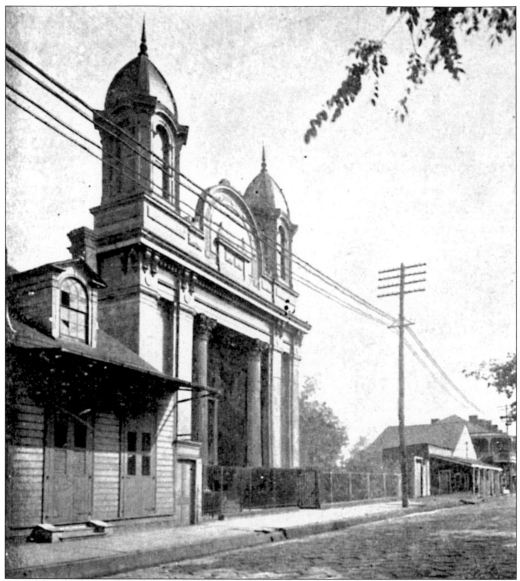

Founded in 1827, Gates of Mercy moved into an existing building in the 500 block of North Rampart in 1843. The building was in some disrepair, and a donations drive for a building began. The drive floundered, influencing Gershom Kursheedt to begin a drive for a Sephardic congregation. With Congregation Dispersed of Judah refurbishing their new synagogue, the members of Gates of Mercy once again sought to rebuild, and thanks in large part to a sizable donation from Judah Touro, the new Gates of Mercy was dedicated in June of 1851.

עד הגל הזה ועדה המצבה
שבית התפלה הזה נדב
לקק נפוצות יהודה
בעד היישיש הנכבד
יהודה טורו
בשנת שמע ה" קול יהודה ואל עמו תביאנו לפק

This building was at first erected and used as a place of worship
for non Israelites; but through the liberality of
JUDAH TOURO (a son of Israel) it was purchased and
donated to the Portuguese "Hebrew Congregation of the
Dispersed of Judah" as a place of prayer to the
MOST HOLY GOD, the SOLE LORD and CREATOR,
to whom be praises everlastingly.
In testimony of which this stone is solemnly deposited
beneath the portal through which the faithful are to enter
to praise the Lord.

NEW ORLEANS { 3d SIVAN, } 5610.
{ 14th MAY, }

Congregation Dispersed of Judah was dedicated in 1850. The former Christ Church building on Canal Street had been renovated, with funds from Judah Touro, to become a synagogue using the Portuguese service. Along with other changes, a stone plaque was sealed into the portal. It commemorated the generosity of Judah Touro, and says, in Hebrew, the following: "This building was first erected and used as a place of worship for non Israelites; but through the liberality of Judah Touro (a son of Israel) it was purchased and donated to the 'Hebrew Congregation of the Dispersed of Judah' as a place of prayer to the Most Holy God, the sole Lord and Creator to whom be praises everlastingly. In testimony of which this stone is solemnly deposited beneath the portal through which the faithful are to enter to praise the Lord."

Congregation Shaare Tefilah, or Gates of Prayer, was chartered in 1850 in the "uptown" suburb of Lafayette City, three miles upriver from the city proper. Like Gates of Mercy, the members were primarily Alsatian and German. The first synagogue was a small, wood structure bought in 1855, located at the corner of St. Mary and Fulton Streets.

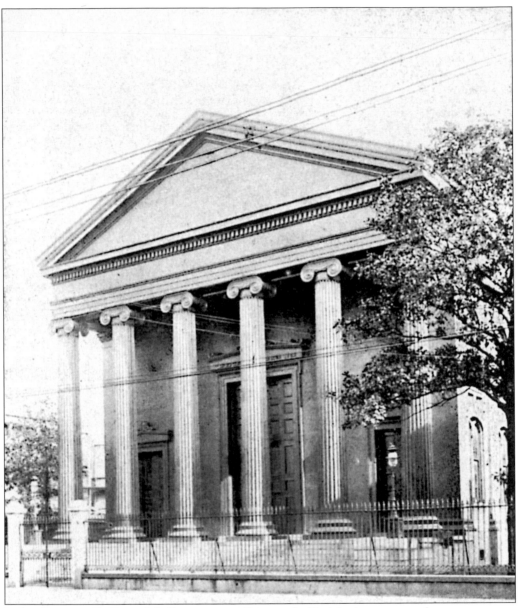

In his famous will, Touro left Congregation Dispersed of Judah the property the synagogue sat on and the large property he owned adjacent, the rents to be used for a Hebrew school and to pay the minister. The building on Canal Street was small, so the congregation decided instead to use the money to build a new synagogue further uptown. The building was completed in 1857. It so resembled the original that many people thought the first building had been moved to the new location.

Because of economic and social differences, the members of Gates of Mercy ignored entreaties from Gates of Prayer for some sort of an amalgamation between the two congregations. In 1859, a brick collection campaign was begun in preparation for building a new synagogue, but due to the Civil War, the sanctuary was not dedicated until 1867.

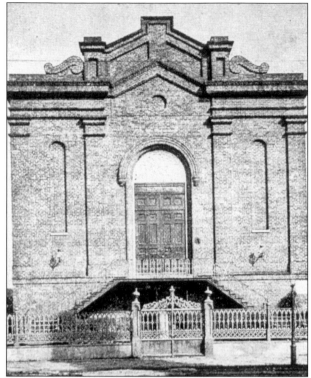

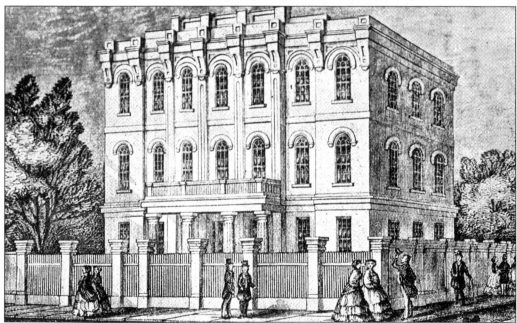

Due to the ravages of yellow fever and other deadly diseases, many women were left widows and many children left orphans. To help those that had lost loved ones, members of the Hebrew Benevolent Association opened the Widows and Orphans Home, only the second such home in the United States. The first site of the Widows and Orphans Home, on Jackson Avenue and Chippewa Street, opened in 1856.

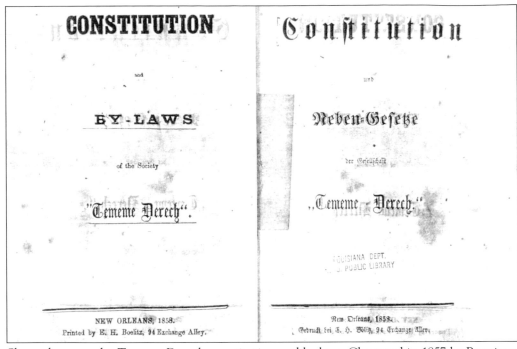

Shown here are the Tememe Derech constitution and by-laws. Chartered in 1857 by Prussians, primarily from Posen, which for most of its history had been part of the Polish Empire, the members practiced the Polish *minhag*, or ritual. This was the only one of the small Eastern European congregations to build its own synagogue, dedicating the building in the 500 block of Carondelet Street in 1867.

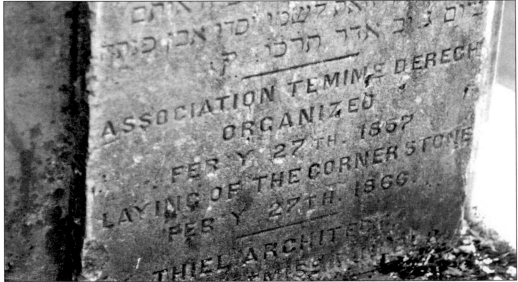

The congregation never had more than 50 members. In 1904, Tememe Derech disbanded, and, together with many of the other small Orthodox congregations, they merged together to form Congregation Beth Israel. This cornerstone now sits in the corner of Beth Israel's "Little Shul," at the congregation's original location on Carondelet Street, even though the congregation moved near the Lakefront in 1970.

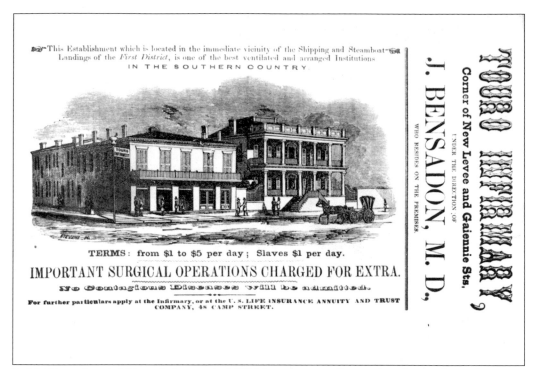

Judah Touro founded Touro Infirmary in 1852 (above) as a small waterfront hospital in a plantation house he purchased at auction from the Paulding estate. It housed 28 patients, with Dr. Joseph Bensadon as house physician. Its first patients were seamen from international ships, slaves, and immigrants often paid for by the Hebrew Benevolent Association of New Orleans. Upon Touro's death in 1854, he willed the "Hebrew Hospital" the property, with the mandate "as a charitable institution for the relief of the indigent sick." He named his executors as directors of the institution. In 1874, the Hebrew Benevolent Association merged with Touro Infirmary to provide financial support for the hospital. Following the yellow-fever epidemic of 1878, Touro Infirmary moved uptown in 1882 (below) to Prytania Street and built a large hospital that served much more of the community.

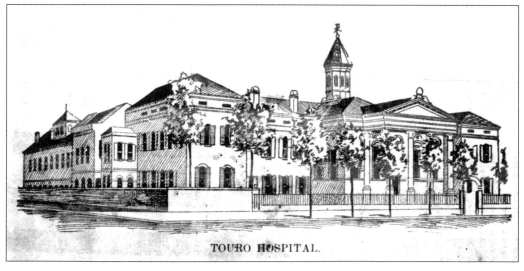

TOURO HOSPITAL.

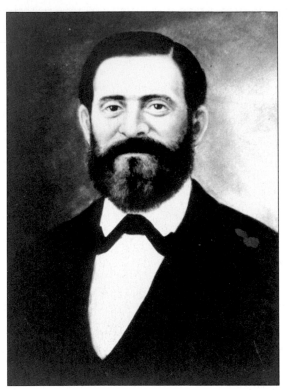

Joseph Bensadon (1819–1871) grew up in Charleston, South Carolina, receiving his medical doctor degree from the Medical Society of South Carolina in 1838. He enlisted in the army in the Mexican War, after which he settled in New Orleans. He had the good fortune to gain the respect and patronage of philanthropist Judah Touro, who purchased a waterfront building at auction to serve as a hospital for seamen initially, but which grew to serve the entire community. Dr. Bensadon was house physician (and almost the entire medical staff) from 1852 until he enlisted in the Confederate Army in 1861. After the end of the war, he returned to New Orleans, where he engaged in private practice until his death.

Elizabeth D. A. Cohen (1820–1921) was the first woman physician in Louisiana. After her marriage to Dr. Aaron Cohen, and the birth of her five children, she enrolled in the Philadelphia College of Medicine, the first women's medical school in the United States. She joined her husband in New Orleans in 1857, and worked side by side with male doctors through yellow fever and other epidemics. She specialized in family practice, mostly treating women and children. In her long life, she said that she had delivered babies of young women she had brought into the world. After her retirement, she entered the Julius Weis Home for the Aged on the Touro Infirmary campus, where she worked as a hospital volunteer. She lived to be 101.

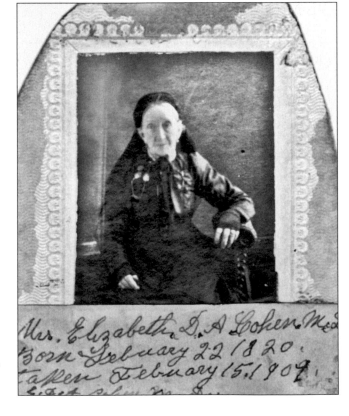

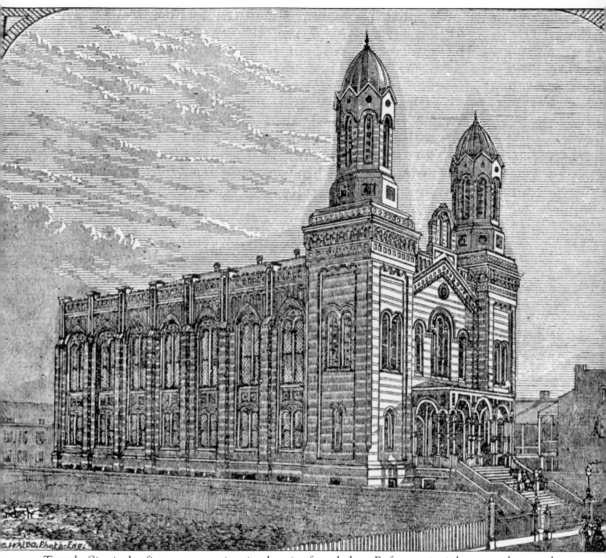

Temple Sinai, the first congregation in the city founded on Reform principles, was chartered in 1870 as a Reform congregation primarily by members of Gates of Mercy who felt that the movement toward Reform at that congregation was stagnating and who wanted a new sanctuary built closer to where the members lived. They also wanted their "temple" to represent the pride and confidence the members felt in proclaiming their Judaism as well as their economic success. The temple was dedicated two years later and was a landmark for years, long after the congregation moved even further uptown in 1928.

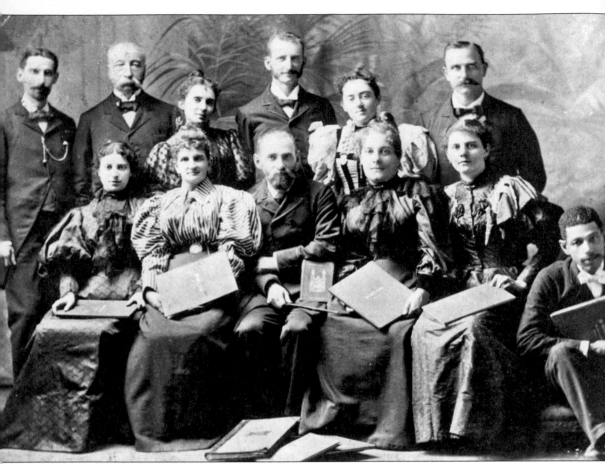

Following the new Reform traditions, Temple Sinai was built with an organ and soon organized a choir, replacing the traditional cantor. This picture of the volunteer choir in about 1890 shows the enthusiasm with which this "Americanization" of the service was greeted. The only person the authors can identify is the white-mustached old gentleman in the back row. He is Leon Cahn, who organized the choir and sometime substituted for clergy. In 1990, Temple Sinai membership voted to engage the services of a cantor, while retaining both choir and organ music.

In the early 1860s, the Deutsche Company was founded "to foster sociability . . . and fellowship" at 112 Common Street. They put on plays and other entertainment. Another group, calling themselves "The Harmony Club" and organized for social purposes, were located on Camp near Julia Street. In 1872, the "Company" consolidated with its younger counterpart and became The Harmony Club at the corner of Exchange Alley and Bienville Street. They were chartered in 1880 for the purpose of "the cultivation of sociability, and the fostering of intellectual culture, . . . and the advancement of the members in science and literature." Among its various locations in the next few years was the beautiful and elaborate building on Canal Street, now occupied by the Boston Club. Their final home, which is pictured here, was on Saint Charles Avenue at the corner of Jackson Avenue.

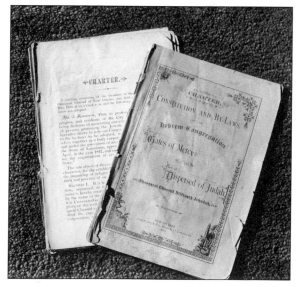

In 1881, the two oldest congregations, Gates of Mercy and Dispersed of Judah, decided to consolidate. Many members of the German congregation had left to join Temple Sinai, and those remaining were decimated by the yellow-fever epidemic in 1878. Dispersed of Judah lost members when many married out of the faith. According to the consolidated charter, members of Dispersed of Judah were granted membership into Gates of Mercy and the conjoined congregation prayed in the Dispersed of Judah synagogue on Carondelet Street.

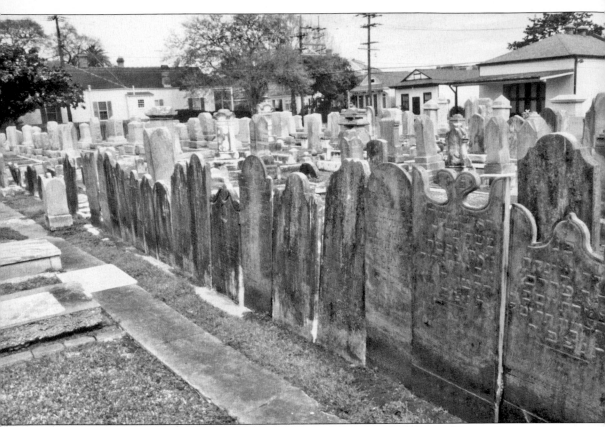

Some of the oldest Jewish headstones in the city are found at the Gates of Prayer Cemetery on Joseph Street. This plot of land was purchased soon after the founding of the congregation in 1850. These early headstones have been saved and placed in line. Most of the early members of the congregation were Alsatians, and many of these early headstones were written in French.

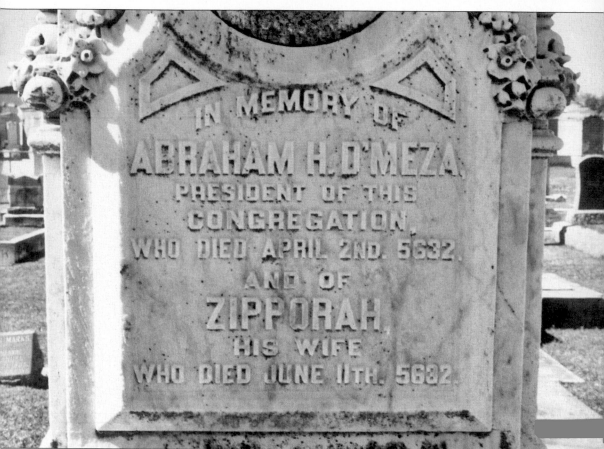

IN MEMORY OF
ABRAHAM H. D'MEZA
PRESIDENT OF THIS
CONGREGATION,
WHO DIED APRIL 2ND. 5632.
AND OF
ZIPPORAH,
HIS WIFE,
WHO DIED JUNE 11TH. 5632.

Picture here are the headstones of Abraham D'Meza, the longtime president of Congregation Dispersed of Judah, and his wife, Zipporah. D'Meza was born in Curacao, just as many of the members of Dispersed of Judah were from the Caribbean and of a Spanish or Portuguese Sephardic background. The year of death is the Hebrew year 5632, which was 1872. The stone was "erected as a token of respect by the congregation" for his years of service.

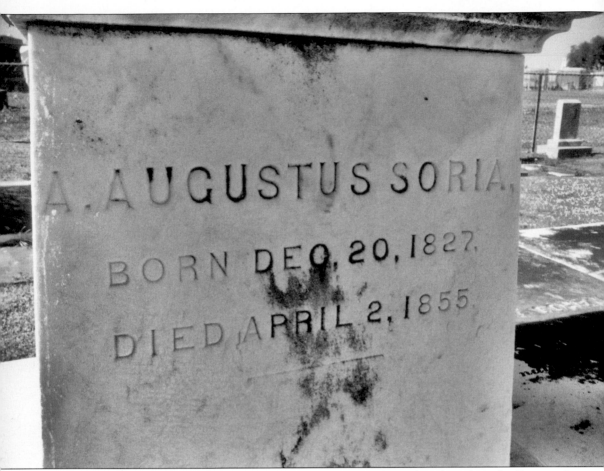

Here is the headstone of A. Augustus Soria. He was one of the earliest burials in the Dispersed of Judah Cemetery. Upon his death in January 1854, Judah Touro was temporarily interred here. In the spring of that year, his body was removed to the Touro family plot in Newport, Rhode Island.

Two

19TH-CENTURY RELIGIOUS LEADERS

Gershom Kursheedt (1817–1863), the grandson of Revolutionary War patriot Rabbi Gershom Mendes Sexias and the son of Israel Baer Kursheedt of Richmond, Virginia, was a close friend and disciple of Isaac Leeser, publisher of the *Occident*. Kursheedt arrived in New Orleans about 1839, where he was active in the publishing and brokerage businesses. But it was his influence on the Jewish community of New Orleans that was his greatest legacy. He found a lax, indifferent, and fairly irreverent group, whose practice of their religion was "unorthodox," to say the least. Kursheedt helped found the Hebrew Benevolent Association in 1844, and organized a new congregation, Dispersed of Judah, to cater to the Sephardic Jews who disliked the service at Gates of Mercy. Most importantly, he attracted the attention of Judah Touro, whom he persuaded to fund the new congregation, but also to contribute to the building fund of Gates of Mercy. His input in Judah Touro's famous will is documented in letters to his friend, Isaac Leeser.

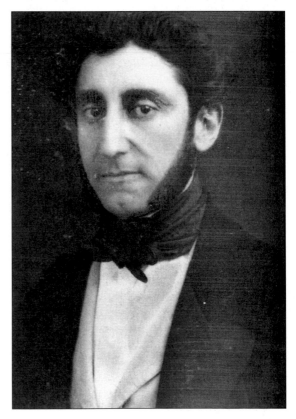

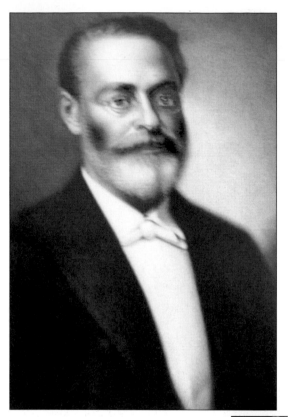

"Reverend" James Koppel Gutheim (1817–1886) was a native of Menne, Westphalia. He studied at the Teachers' Seminary in Muenster and with Rabbi Abraham Sutro, who granted Gutheim a diploma in Hebrew proficiency but without rabbinical ordination. He arrived in New York in 1843, where he taught Hebrew school. He moved to Cincinnati in 1846 to serve as reader at Bene Israel before moving to Bene Jeshurun the following year. Gutheim came to New Orleans as minister at the Ashkenazi congregation Gates of Mercy in 1850 but moved to the Sephardic Dispersed of Judah three years later. He left the city during the Civil War occupation rather than take an oath of allegiance to the Union. After the war he returned, this time to Gates of Mercy, where he soon began instituting reforms in the ritual. Feeling reform was moving too slowly, he left for New York in 1868 to become reader at Temple Emanuel. But with the creation of Temple Sinai, Gutheim returned and was named rabbi, and he stayed there until his death in 1886.

Metairie Cemetery, originally a race track, was ordered closed by Gen. Benjamin Butler, commanding general of Union forces in New Orleans, and turned into a bivouac for Union soldiers. After the war it was felt that the only thing this ground was good for, after being soiled by Union soldiers, was a cemetery. Over the years it became a point of pride among the local elite to be buried in Metairie Cemetery. In 1885, some Jewish business leaders approached Reverend Gutheim and asked whether it would be acceptable for Jews to be buried here. Gutheim was assured that Jewish burial laws would be adhered to; all burials would be below ground and the Jewish plots would be separated from Gentile plots. Gutheim gave his blessing, and just months later died, making him the first Jew to be buried in Metairie Cemetery.

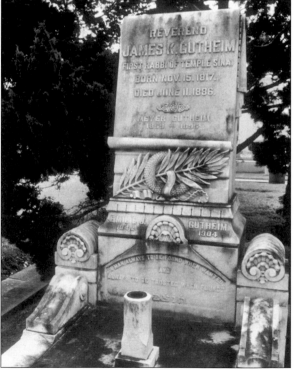

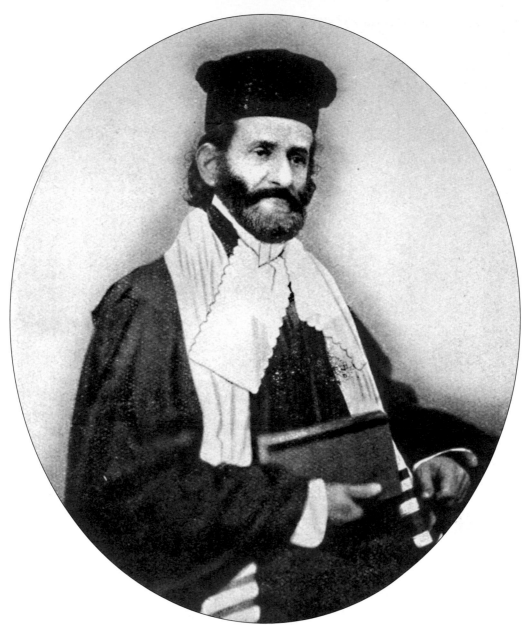

Bernard Illowy (1814–1871), only the second ordained rabbi in the United States, came from a long line of learned rabbis. He arrived in this country in 1850, and over the next 10 years served congregations in New York, Philadelphia, St. Louis, Syracuse, and Baltimore, before coming to Gates of Mercy in New Orleans in 1861. Throughout the 1850s his was a leading voice in opposition to the newly evolving Reform movement in American Judaism, writing articles and letters that appeared in the various Jewish periodicals of the day. Soon after his arrival in New Orleans, he began berating his congregants regarding their religious laxity, the unintended consequence of which was to stimulate a reform movement within his own congregation, eventually resulting in the creation of Temple Sinai. He left New Orleans for Cincinnati in 1865. Gutheim was soon to return to the city and Illowy realized the majority of the congregation preferred Gutheim. In Cincinnati, he renewed acquaintance with his rival and friend, Isaac Meyer Wise.

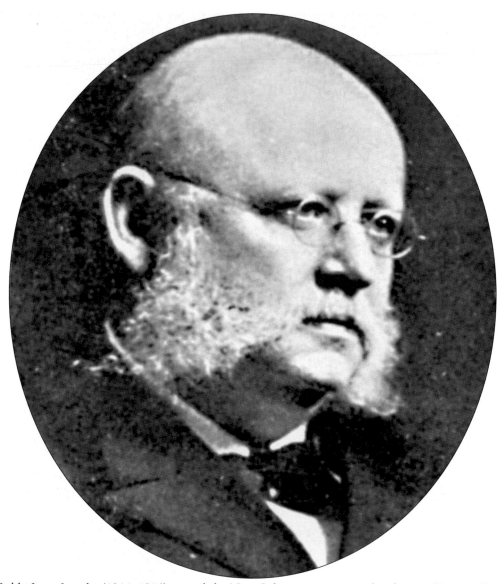

Rabbi Isaac Leucht (1844–1916) served the New Orleans community for close to 50 years. Born in Hesse, he arrived in New Orleans in 1868 as cantor for Gates of Mercy. Just months after his arrival, Gutheim left for New York, and Leucht took on the added responsibility of minister. Four years later, he left to become cantor at Temple Sinai. He returned to Gates of Mercy in 1879 after both the minister and cantor were struck down by yellow fever. Two years later, the two oldest congregations consolidated to create The Gates of Mercy of the Dispersed of Judah, with Leucht as minister. Leucht was the first to call the congregation Touro Synagogue, in honor of the benefactor of the two earlier congregations. Over the next 10 years, Leucht guided the congregation toward Reform, sometimes patiently, sometimes irascibly. He served as vice president of the Touro Infirmary and Hebrew Benevolent Association as well as president of the Widows and Orphans Home, in which capacity he was a driving force behind the creation of Newman School. Like Gutheim, Leucht was also a bridge to the Gentile community, serving as president of the Louisiana Red Cross, a member of the Louisiana State Board of Education, president of the Commission on Prisons and Asylums, and vice president of Kingsley House.

Rabbi Max Heller (1860–1929) was born in Prague, Bohemia, where he continued his medical studies after his parents moved to Chicago. He came to America in 1879 and soon entered the Hebrew Union College and the University of Cincinnati. His first pulpit was in Houston, but just one year later, thanks in large part to a vigorous letter writing campaign by Rabbi Isaac Meyer Wise, Heller was selected to replace the deceased Reverend Gutheim at Temple Sinai. He served Sinai for the next 40 years, his white beard earning his the sobriquet "the man who looks like God." Heller was an ardent Zionist, a rare commodity that often found him at odds with the majority of Reform Jews throughout the country and in his own congregation. He was a leader in the fight to abolish the Louisiana lottery and served as a member of the Louisiana Board of Education. Heller was professor of Hebrew language and literature at Tulane University. He served as both president and vice president of the Central Conference of American Rabbis.

Moses Heidenheim (1825–1907) was born in the city of Darmstadt, in the German principality of Hesse, in 1826. He arrived in New Orleans in 1848, and began by pushing a cart around the surrounding parishes. He eventually opened a clothing store at the corner of Jackson Avenue and Tchoupitoulas Street. He joined Gates of Prayer and soon became a congregational leader, serving as president from 1862 to 1863 and then continuously from 1875 until 1897.

Samson Cerf (1840–1905), Heidenheim's son-in-law, was born in Alsace and came to New Orleans in 1861. Deeply religious, Cerf served Gates of Prayer as minister and cantor from the time of his arrival in 1861 until 1869. He served for many years as a faculty member of the congregational religious school.

Three

19TH-CENTURY COMMUNITY LEADERS

Born in Kaiserslautern, Rhenish Bavaria, Isidore Newman (1837–1909) came to America, penniless, in 1853 and soon saved enough money to bring his brothers, Henry and Charles, to Louisiana. They started a cotton brokerage in Harrisonburg, Louisiana, but the business failed. Then Newman moved to New Orleans and became a bookkeeper for Henry Stern. After the Civil War he went into banking. In 1873, he advanced the city enough money to meet its payroll. Newman helped organize the New Orleans Stock Exchange and was for many years its president. He financed railways in several cities, including New Orleans, and was the major financial backer of Maison Blanche. In 1903, he endowed the Jewish Children's Home to create the Isidore Newman Manuel Training School. He was awarded the *Daily Picayune* Loving Cup in 1903.

Julius Weis (1826–1909) was born in Klingen, Rheinpfalz, Germany. He came to New Orleans in 1845 but became a peddler in Mississippi. He saved enough money to open a dry-goods store in Fayette, Mississippi. Three years later, he moved to Jackson and became a partner at Mayer, Deutsch, & Weis. In 1864, his partners sent him to New Orleans to open a dry-goods store, but within a year he found it far more profitable buying and selling cotton, and he quickly made his fortune. Weis was a charter member of Temple Sinai and was a leader in the establishment of the first Jewish school in New Orleans, started in 1866 by the Hebrew Educational Society. In 1880, he was elected president of the Touro Infirmary, and as such, he led the fund-raising for the building of the new hospital on Prytania Street. The Touro Home for the Aged and Infirmed was eventually named in his honor, after a gift by his children.

Born in Hamburg, Joseph Magner (1828–1908) arrived in New Orleans in 1848. Before the Civil War, he was a bookkeeper, but after the war he became an insurance agent. He was a charter member of Temple Sinai. He served as both secretary and president of the Touro Infirmary, secretary of the Hebrew Benevolent Association, chairman of the board of managers of the Orphans' Home, the first president of the Young Men's Hebrew Association (YMHA), and was a longtime member of B'nai Brith.

At the age of 19, Benjamin Franklin Jonas (1843–1902) moved to New Orleans from Illinois. "Frank" Jonas was admitted to the bar and went into the law firm of Henry M. Hyams, a cousin of Judah P. Benjamin. Jonas became active in the New Orleans Jewish community and was a founding father of the Jewish Widows and Orphans Home. He served in the Civil War, one of the many fighting from the Jonas family, some on the Confederate side, some on the Union side. After the war, he became active in Louisiana politics, serving as a state senator and city attorney of New Orleans, and in 1879 he was elected to the United States Senate from Louisiana.

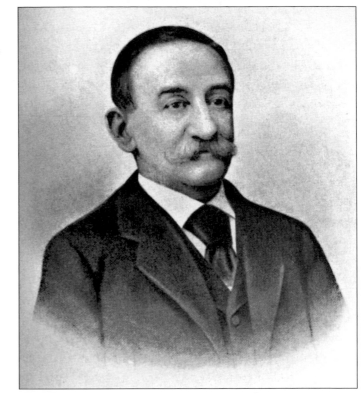

A founding member of the Jewish Widows and Orphans Home and the Touro Infirmary Corporation, George Jonas (1828–1911) served as the first president of the Touro Infirmary board of managers in 1854, following Judah Touro's death. The family originally came to America from England and settled in Illinois, before some of the brothers moved to Louisiana. George Jonas served in the Louisiana militia during the Civil War and returned to New Orleans to become president of the Canal Bank.

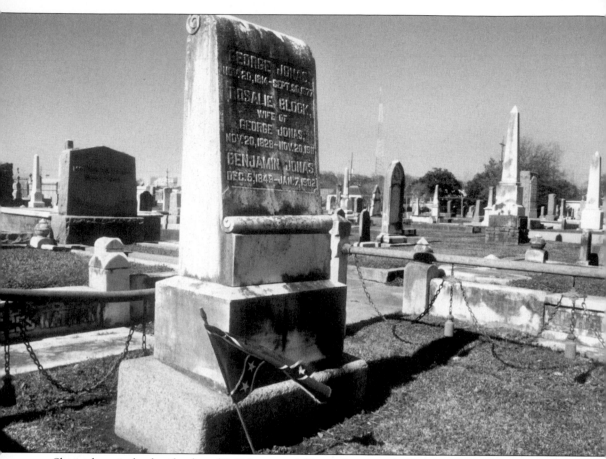

GEORGE JONAS
NOV. 20, 1814–SEPT. 20, 1877
ROSALIE BLOCK
WIFE OF
GEORGE JONAS
NOV. 20, 1828–NOV. 20, 1911
BENJAMIN JONAS
DEC. 5, 1843–JAN. 7, 1902

Shown here is the family plot of B. F. Jonas and George Jonas at the Dispersed of Judah Cemetery. Both served in the Confederate Army during the Civil War. The Rebel flag was replaced on a regular basis up until the last few years.

Col. Edwin I. Kursheedt (1838–1906), nephew of Gershom Kursheedt, was born in Kingston, Jamaica, in 1838, came to New Orleans at a young age, and was educated in the public schools. During the Civil War, he served in the Confederate Army as a member of the Washington Artillery and was wounded at the Battles of Antietam and Fredericksburg. In the years following the war, he became a prominent Democratic politician.

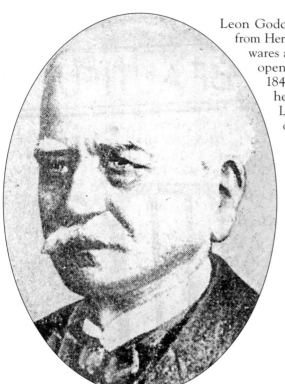

Leon Godchaux (1824–1899) arrived in Louisiana from Herberville, France, in 1840. He began selling wares along the inland roads and did so well he opened a general store three years later. By 1844, he had settled in New Orleans, where he opened a store that eventually became Leon Godchaux's Clothing Store. Godchaux owned sugar plantations in Reserve, Napoleonville, and Raceland, Louisiana, among others, and refined the sugar on site, all under the umbrella of the Godchaux Sugar Company.

In 1844, 20-year-old Leon Godchaux opened a retail store at 213 Old Levee Street (now Decatur) between Dumaine and Madison Streets. He lived above the store. He was so successful that he was able to buy property on Canal Street near Chartres and build a six-story building. On the upper floor, he manufactured men's summer suits, which he sold in the retail department on the lower floors. After Leon Godchaux's death in 1899, his seven sons headed his various businesses. In 1924, Godchaux Store moved to 828 Canal Street, into the building pictured, which had been built at the turn of the 20th century.

Aaron Steeg came to the United States from Germany in 1868 at the age of 15. He first worked as a clerk and retail merchant in various businesses. In 1895, Mr. Steeg founded *The Jewish Ledger,* one of the most influential Jewish journals in the country, which continued publication until 1963. He became president in 1902 of The Merchants' Printing Company, which published *The Jewish Ledger,* and also *The Square and Compass,* a Masonic journal. Aaron Steeg's son, Moise, continued the publication until his death. His son, Moise Steeg Jr., published the *Ledger* until he left to serve in the Navy in World War II. A graduate of Tulane Law School in 1937, Moise Steeg Jr. became a prominent lawyer and civic leader, whose contributions to a better New Orleans have been rewarded by the *Times Picayune* with the presentation of the 2004 Loving Cup.

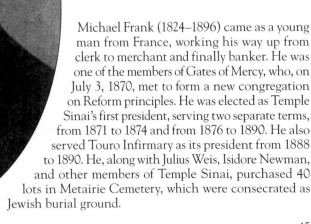

Michael Frank (1824–1896) came as a young man from France, working his way up from clerk to merchant and finally banker. He was one of the members of Gates of Mercy, who, on July 3, 1870, met to form a new congregation on Reform principles. He was elected as Temple Sinai's first president, serving two separate terms, from 1871 to 1874 and from 1876 to 1890. He also served Touro Infirmary as its president from 1888 to 1890. He, along with Julius Weis, Isidore Newman, and other members of Temple Sinai, purchased 40 lots in Metairie Cemetery, which were consecrated as Jewish burial ground.

Gus Mayer (1876–1952) was a native New Orleanian and a graduate of the Soule Commercial College. After graduation, he went into retail sales. His department store, located at 823 Canal Street, specialized in ladies' and children's furnishings.

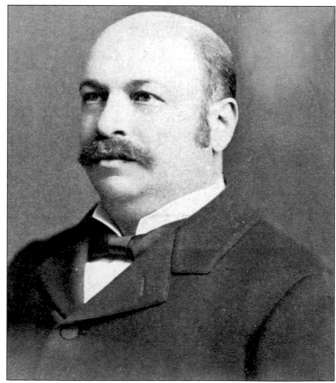

Mayer Israel (1867–1915) owned one of the most popular department stores on Canal Street. He was a member of the Hebrew Benevolent Association and the Children's Home, as well as the local B'nai Brith, YMHA, and the Harmony Club.

Marks Isaacs (1852–1910) was one of the first to go into the department store business in New Orleans, opening his first store in 1879. He joined Charles Kaufman in opening the Kaufman and Isaacs store on Dryades Street before becoming president of Schwartz & Isaacs Company, which operated the famous "Maison Blanche" store at Canal and Dauphine Streets. In 1907, he built a large home on Saint Charles Avenue today known as Latter Library, which is on the National Register of Historic Places.

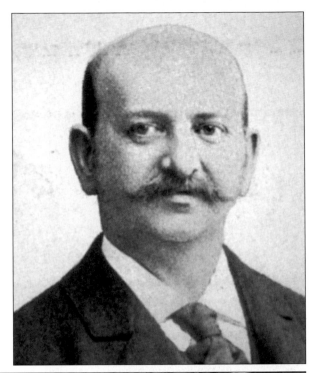

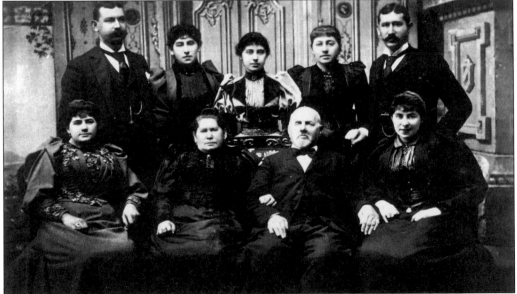

Michael Pokorny (bottom center), born in 1829 in Moravia (now part of the Czech Republic), was a master shoemaker in Budapest before coming to the United States in 1856 with his wife, Fanny. He arrived in New Orleans in 1860, and during the Civil War worked at nearby Camp Moore making shoes for Confederate soldiers. After the war and Reconstruction, Pokorny operated a large wholesale dealership of shoes doing business in Southern states, providing shoes and boots for sugar and cotton planters. He then went into the retail business, opening stores on Poydras and Royal Streets and Saint Charles Avenue. In 1883, he became blind and crippled, but continued his business and civic activities until his death in 1902.

Born in Alsace, Moise Waldhorn (1872–1910) arrived in New Orleans in the 1870s and in 1881 opened a shop on the corner of Royal and Conti Streets in the French Quarter. At first he bought jewelry and curios from impoverished Creoles, suffering after the Civil War, but by the time of his death, he had established Waldhorns as an antique shop, the first one in New Orleans. After his death, his business continued under the helm of his son, Samuel Waldhorn, and later his great-grandson, Steven Moses. The trophy that rewards the winner of the annual Sugar Bowl football game was an antique English sterling wine cooler, presented to the Sugar Bowl committee in 1934 by Sam Waldhorn. In 1997, the business was purchased by Coleman Adler Jewelers, which maintains a combination antique and fine jewelry company in the original building.

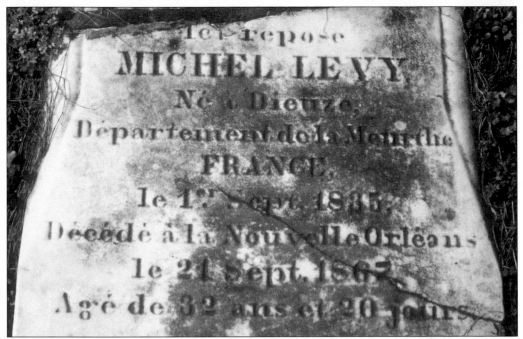

Shown is the headstone of Michel Levy; the writing is French. Levy died in 1867 and was buried in the first Jewish cemetery in the city, the Gates of Mercy Cemetery on Jackson Avenue. The city expropriated a portion of the cemetery, forcing the congregation to exhume the bodies and move them to their second cemetery on Elysian Fields Avenue, Hebrew Rest No. 1. Many older headstones, such as Levy's, were simply laid on the ground.

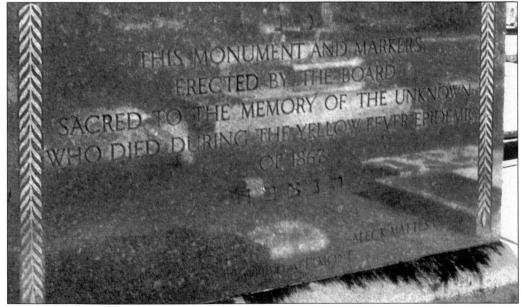

New Orleans was hit with a particularly deadly yellow-fever epidemic in 1867. So many died so quickly that many people were buried in mass graves. The executors of the Tememe Derech Cemetery—Dr. J. E. Isaacson, Aleck Mattes, and Mrs. Alfred Allmont—erected this memorial in 1932 to the memory of those buried in that manner.

This chair in Dispersed of Judah Cemetery was made a part of the headstone of Lilla Benjamin Wolf, wife of Isaac Wolf, who died October 12, 1911. Legend has it that she would sit in her chair outside the family business and encourage passersby to enter the store and shop.

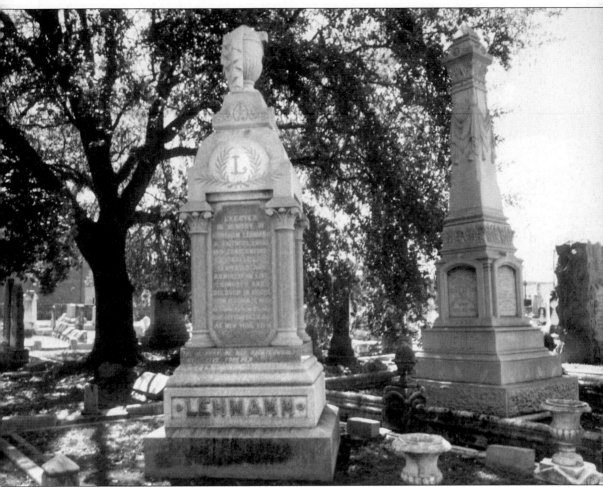

Abraham Lehmann (1833–1895) was born in Bavaria in 1833 and died while visiting New York in 1895. A successful businessman, Lehmann was, as his headstone reads, a "Faithful, Loyal & Conscientious Israelite." As a member of Gates of Mercy, he served as a member of the last, and probably only, beth din—a Jewish legal proceeding—to ever take place in New Orleans. At Gates of Mercy, and later as president of Touro Synagogue, he stoutly defended traditional Judaism even as the congregation moved more and more toward Reform. He is buried in Hebrew Rest No. 1.

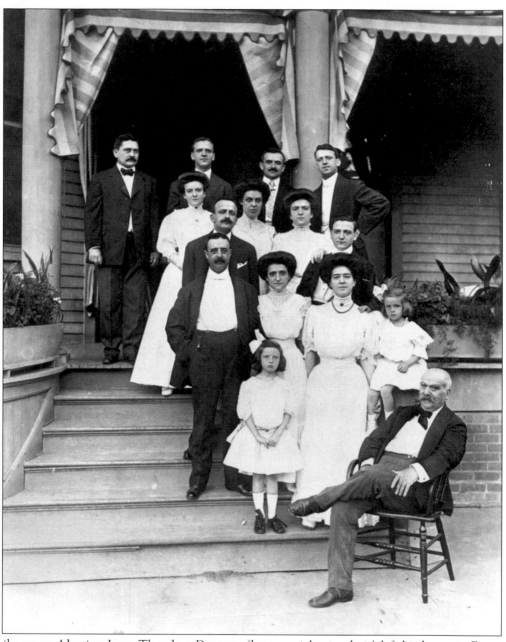

Like many Alsatian Jews, Theodore Dennery (bottom right, in chair) left his home in France after the Franco-Prussian War because he refused to become German. He settled with his family in New Orleans because French was spoken in the streets and he felt at home. He began selling yeast to bakers and confectioners in the area. His oldest son, Charles Dennery, began a bakery supply business in 1894, which employed his three brothers, Ralph, Morris, and Georges, as well as his brothers-in-law, Albert Schwartz and Fred Kahn. Charles Dennery, Inc. sold equipment and food supplies to restaurants, bakeries, and hotels all over the South and Southwest, with offices in Houston, Dallas, and Atlanta, as well as New Orleans. They were bought by DCA Food Industries in 1964 and closed in 2001. Their best-known and loved product was a legendary chocolate fudge sauce, the loss of which is lamented to this day.

After serving his apprenticeship in his father, Abel Dreyfous's, notarial office, Felix J. Dreyfous (1857–1946) graduated from Tulane University in the law class of 1888. He was elected to the state legislature, where he authored bills opposing the corrupt Louisiana Lottery and others that proposed flood control and police reform. He was instrumental in founding the Legal Aid Society of New Orleans. He was a delegate to the Union of American Hebrew Congregations, where he served on the committee on civil and religious rights. His most visible legacy to the people of New Orleans was the creation of City Park in 1891. He received the *Times Picayune* Loving Cup in 1933.

Born in Kingston, Jamaica, Isaac Delgado (1839–1912) arrived in New Orleans in 1854. He took up residence with his uncle, Samuel Delgado, and the two became sugar and molasses agents, opening Delgado and Company in 1857. They became two of the city's leading citizens, and, influenced by Samuel's wife, avid art collectors. This led to his offer in 1910 to build an art museum in City Park. The museum was completed the following year, but he died soon after, in January 1912. In 1971, the Isaac Delgado Museum was renamed the New Orleans Museum of Art.

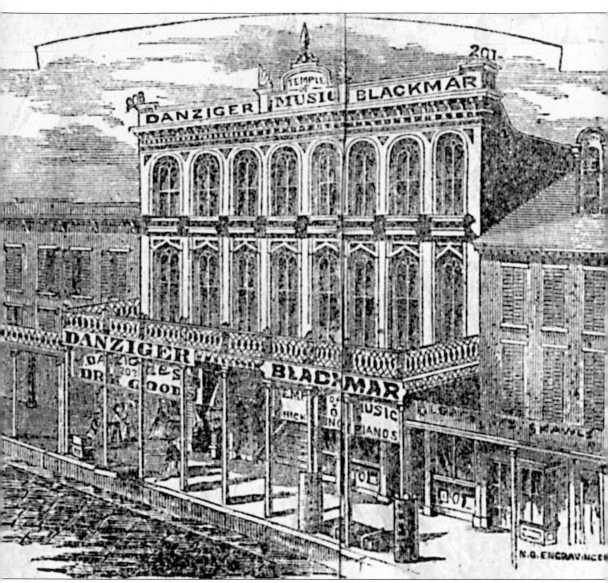

Opened by Theodore Danziger, a native of France, in 1848, Danziger's was one of the leading dry-goods houses of the South. It was first located at the corner of Royal and St. Philip Streets in the French Quarter and later relocated at 131 Canal Street, in a building that they shared with Blackmar Music Company. Theodore Danziger was joined in business by his two sons, Isidore and David Danziger, who carried on the business after their father's death in 1874. They were known for a splendid stock of fancy silks, cashmeres, and even ladies' ready-to-wear. The drawing of the building is from wrapping paper that contained a pair of ladies' white kid gloves.

Burials began in this cemetery, fronting along Canal Street, as early as 1860 by Congregation Tememe Derech. In 1865, Gates of Prayer purchased adjacent property, but did not begin to use it for burials for some 80 years. By the 1880s, both Chevra Thilim and Chevra Mikve Israel were using the cemetery. Part of the property was leased to Beth Israel before they bought their own cemetery on Frenchmen Street in the 1930s. This gate, originally erected along the side street, was moved to face the front along Canal Street in 2004.

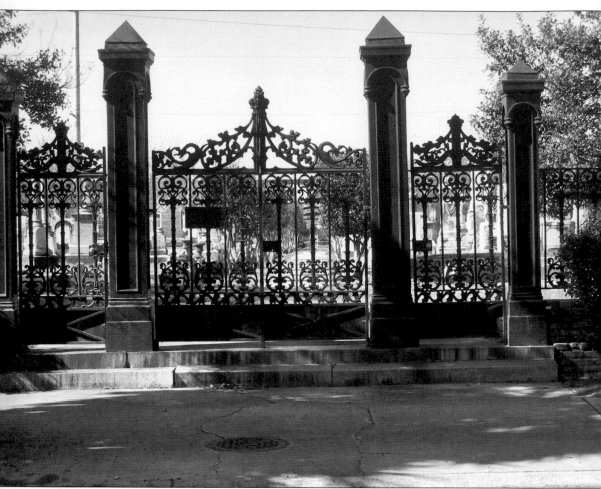

Gates of Mercy Congregation bought property in the Third District—bounded by Elysian Fields, Pelopidas, Frenchman, and Solon Streets—from Michael Lorenz in 1860 as the space in their original cemetery on Jackson Avenue filled up. In 1868, Gates of Mercy was informed that part of the original cemetery was being appropriated by the city to widen the street. The remains were symbolically exhumed and removed to the new cemetery on Elysian Fields Avenue. In 1872, half the property was purchased by Temple Sinai, and the two congregations gave all rights to the Hebrew Rest Cemetery Association, which today comprises both Temple Sinai and Touro Synagogue. Additional purchases of property have been made through the years. The gates shown are on the Elysian Fields entrance to the oldest section of the cemetery.

Four

MOVING UPTOWN

Rabbi Leucht, seated at right, served as first vice president of the Touro Infirmary and Hebrew Benevolent Association and chairman of the committee on education, discipline, and health of the Jewish Children's Home. As such he was instrumental in the creation of a manual-training school for the children living in the home.

Touro Infirmary's board of managers instituted a fund-raising program in an effort to attract donors who wished to memorialized loved ones with a gift less expensive than a marble plaque on the hospital walls. The Golden Book of Life was created with an engraving heading every page that tells us today how close was the relationship between Touro Infirmary, the Jewish Widows and Orphans Home, Temple Sinai, and Touro Synagogue. Any list of their directors will reveal

the same names. In the center is the new Touro Infirmary, on Prytania Street. To the left is the elaborate new Jewish Widows and Orphans Home. To the right is the Dispersed of Judah Synagogue building on Carondelet Street, which had just been named Touro Synagogue, with the spires of Temple Sinai peaking over the rooftop. There are entries from 1887 to 1934.

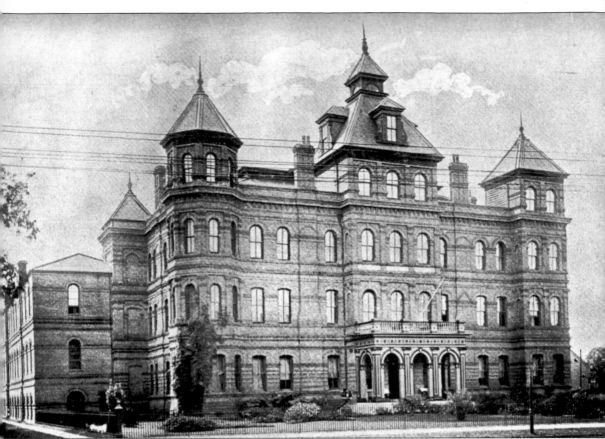

In 1881, a new, larger Widows and Orphans Home was built, far out in the suburb, on the corner of St. Charles Avenue and what was then Peters Avenue, now Jefferson Avenue. By the late 1940s, the few remaining children were put into foster homes, and the building became the Jewish Community Center. The building was torn down in 1963 and a new Jewish Community Center building was erected on the property.

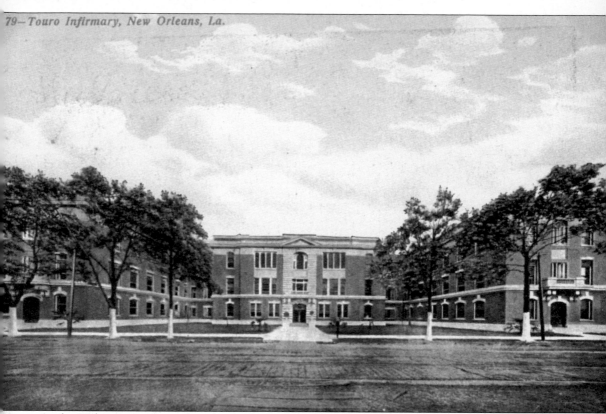

As the 20th century dawned, under the leadership of Presidents Nathan I. Shwartz and Sam Blum and medical director William Kohlmann, M.D., Touro Infirmary embarked on a campaign to fund a new "fireproof" brick hospital on the Prytania Street site of the 1882 wooden building. Screens over the cisterns prevented mosquitoes from breeding in stagnant water, and netting protected the beds. When New Orleans's final yellow-fever epidemic struck, Superintendent John Ellis was able to report "not one case in the Touro thanks to the screens."

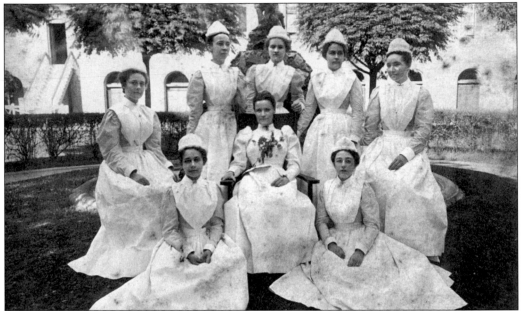

One of the oldest nursing schools in New Orleans, Touro Infirmary School of Nursing opened in 1896. At that time, nursing was thought of as suitable only for nuns and married women. Before the nursing school opened, Touro's first nurses were men. Several accounts by members of the early nursing classes recount the opposition of the young ladies' families to their choice of profession. The nursing school prospered through yellow fever, two world wars, integration, and the addition of male nursing students. It closed in 1987 because the nursing profession demanded a college degree, not just a diploma from a hospital.

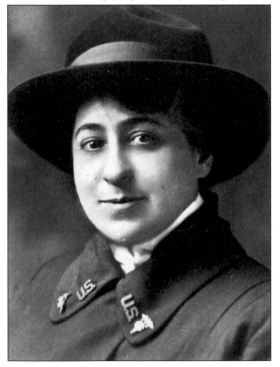

Although New Orleans claims Amelia Greenwald (1881–1966) as its own, she truly belongs to the world. Born in Gainsville, Alabama, into a prominent family, her great desire was to become a nurse, in spite of her family's protests. She trained in one of the earliest classes at the Touro Infirmary School of Nursing, graduating in 1908, and continued her studies at Johns Hopkins and Columbia Universities. During World War I she served with the American Expeditionary Forces as chief nurse in Verdun, France. After the war, she established the Jewish Nurses Training School in Warsaw. She retired from nursing to a small city in Southwest Louisiana, where she owned a dress shop.

In 1899, Touro Infirmary opened a separate home for the aged and infirmed on the Touro campus. The children of Julius Weis, former president of Touro Infirmary, donated $25,000 in his honor toward the erection of the building as a "separate building was necessary to make the old folks more comfortable." The home was closed in 1930, and the remaining residents were moved to the B'nai Brith Home for the Aged in Memphis. The bottom picture is of the home's chapel.

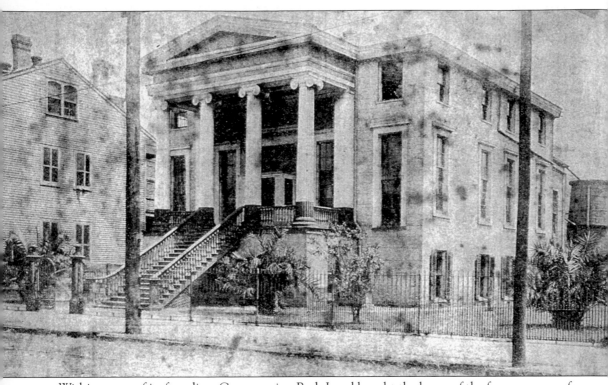

Within a year of its founding, Congregation Beth Israel bought the home of the former mayor of the city, Joseph Shakspeare, in the 1600 block of Carondelet Street, and after remodeling, held services there, beginning in 1905.

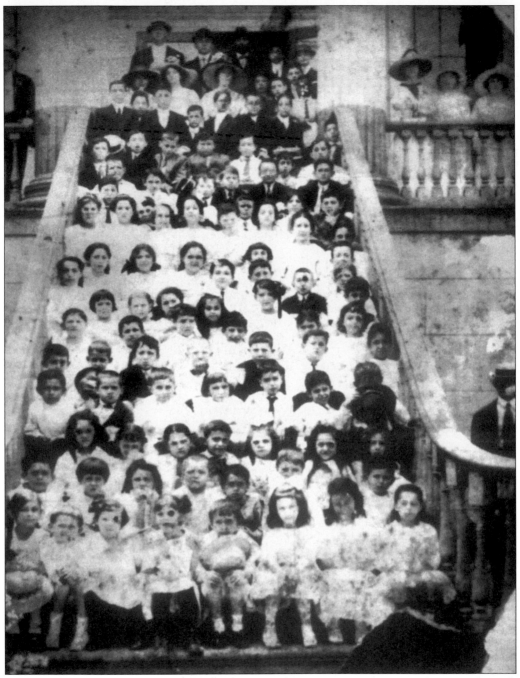

Beth Israel grew quickly. By 1910, it was the second-largest congregation in the city. Through World War II, the congregation often referred to itself as the "largest Orthodox congregation in the South." Here is the Sunday school around 1912.

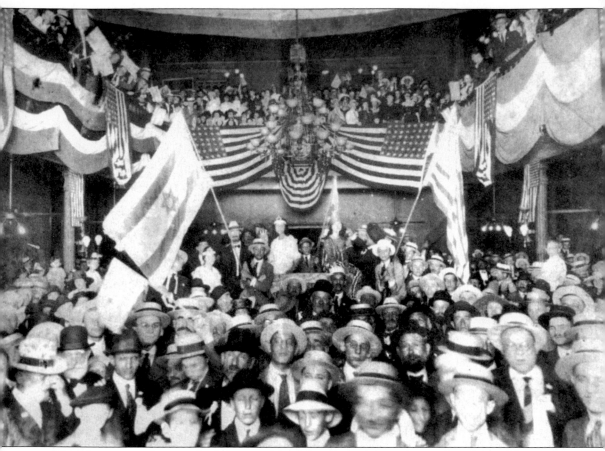

This photo was taken inside the original Beth Israel in 1917, as they gathered to celebrate the announcement of the Balfour Declaration. Notice at the bottom left the man with his hand raised toward his eyes. That is Rabbi Heller of Temple Sinai, an ardent Zionist at a time when few Reforms Jews supported Zionism.

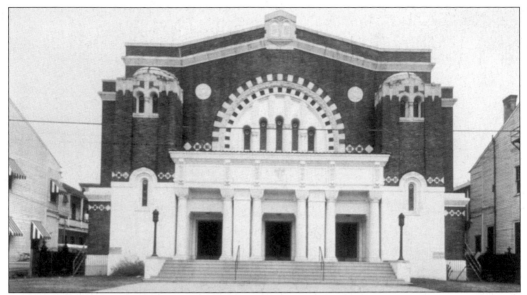

The original Beth Israel building was torn down and a new synagogue built on the same location in 1924. The building featured hand-carved Stars of David in the ceiling, a magnificent chandelier imported from Europe, and beautiful stained-glass windows, all of which highlighted the growing economic and social confidence of the membership. But by the 1930s, the neighborhood began to deteriorate; members moved farther uptown, and talk of moving the congregation also began. In 1971, the congregation moved to Canal Boulevard, near the Lakefront.

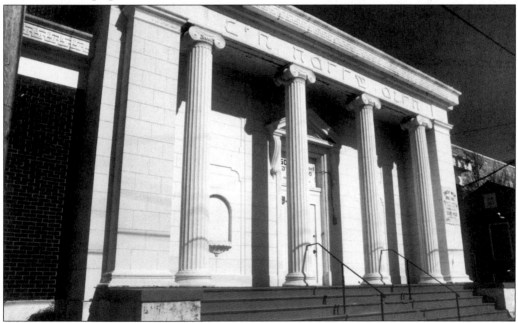

In 1926, the congregation erected the Menorah Talmud Torah to serve as an office and school building. It housed a nursery school, a Hebrew school, and a Sunday school. The building also housed the "Little Shul," where *minyon*, or services, were held twice daily. The water fountain, installed at the urging of David Gertler in the early 1950s, provided the coldest drinking water in the city.

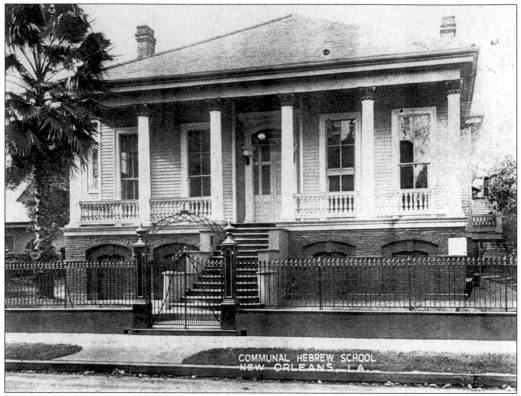

First proposed at a general meeting of the Orthodox community in 1902, the Communal Hebrew School did not begin holding classes until 1915. The first school, pictured above, was on Josephine Street. Run in an "orthodox" manner, by 1920 children whose families belonged to all the congregations in the city, including the Reform, were attending. By the middle of the decade, the members of Beth Israel decided to begin their own Hebrew school so that their children would not be attending school with children of Reform families.

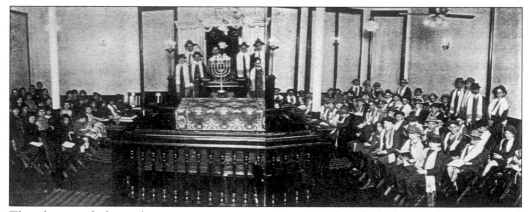

This photograph shows the junior congregation at Communal, with the boys and girls separated. Standing to the right of the menorah is Dr. Ephraim Litzitsky, the longtime head of the school. Litzitsky was very much a scholar in his own right, composing poetry in Hebrew and translating Shakespeare into Hebrew and Yiddish.

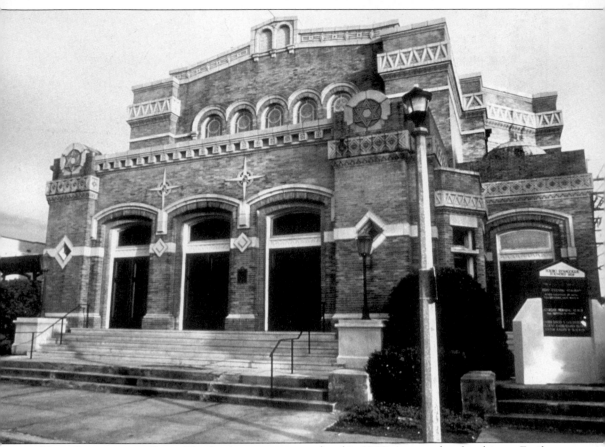

Touro Synagogue on Saint Charles Avenue was completed in 1909. A young local architect, Emile Weil, won a competition to design the new sanctuary, a striking neo-Byzantine, domed edifice. Inside, the original pillars of the Ark of the Covenant traces its heritage back to the original Dispersed of Judah synagogue on Canal Street and to Judah Touro, who insisted on authentic cedars of Lebanon.

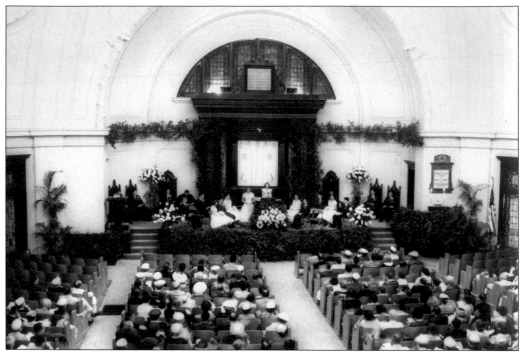

Shown here is a confirmation celebration at Touro Synagogue, sometime in the 1920s. The ceremony includes both boys and girls, making it the preferred ceremony in Reform congregations to the bar or bat mitzvah service.

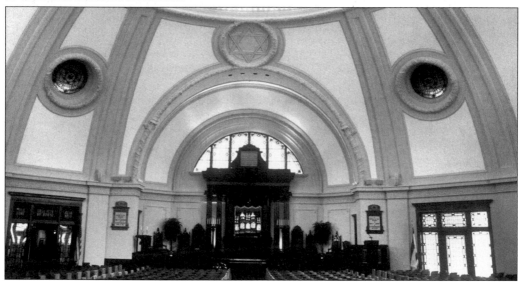

The cedars of Lebanon that comprised the interior pillars of the Ark at Touro Synagogue were shipped to New Orleans by Judah Touro on one of his vessels and presented to Congregation Dispersed of Judah and dedicated in 1850. The Ark was removed to the second Dispersed of Judah synagogue on Carondelet Street. After the consolidation of Dispersed of Judah with Gates of Mercy in 1881, the new congregation soon adopted the name Touro Synagogue. In 1909, the congregation moved to its present location on Saint Charles Avenue, and the historic Ark was moved also.

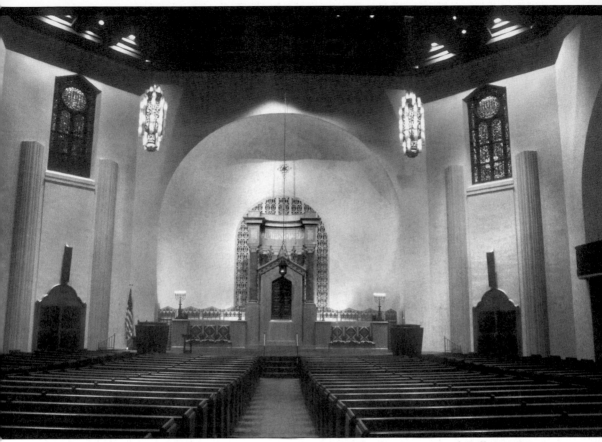

In 1928, Congregation Temple Sinai moved uptown to St. Charles Avenue and Calhoun Street, into the building that they now occupy, with many additions, including a religious school and a chapel. For many years, the old temple building survived various uses, including a theater, until it was demolished in the 1960s. Its two towers were salvaged by a collector of architecture, and can still be seen on a building on Bottinelli Place off Canal Street.

A small group of Galitzeaners began holding *minyans* (services) in the homes of members as early as 1875. Congregation Chevra Thilim, "the Society of the Psalms," incorporated in 1887. It was another 25 years before the members of this small congregation would have their own house of worship. In 1915, Benjamin Rosenberg built and donated a building to serve as the synagogue at 826 Lafayette Street. The congregation moved further uptown in 1949. In the late 1950s, a lengthy debate over mixed seating eventually resulted in a schism within the congregation, paving the way for the creation of the city's first Conservative congregation.

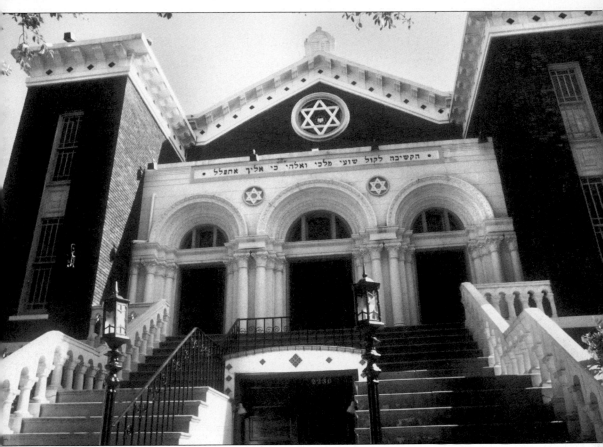

Congregation Agudath Achim Anshe Sfard, "the United Brothers of the Sephardic Rite," was organized in 1896 by Polish, Russian, and Lithuanian Jews. In 1900, the congregation purchased the building at 1309 South Rampart Street. The congregation outgrew that building, and a new synagogue was built at 2230 Carondelet Street in 1925. Over time, the Orthodox families that prospered in this Dryades Street neighborhood began to move further uptown. The neighborhood deteriorated. Most families moved away. But Anshe Sfard remains, a beautiful reminder of the once vital New Orleans Orthodox community.

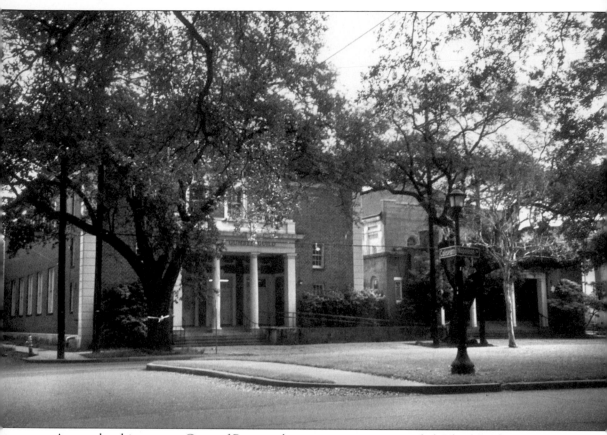

As membership grew at Gates of Prayer, a larger synagogue was needed. The Napoleon Avenue Presbyterian Church stood at the corner of Napoleon and Coliseum Streets, and in 1919 the building was purchased to become the new Gates of Prayer synagogue. The dedication took place May 14, 1920. Rabbi Silber gave the sermon, then Rabbi Heller of Temple Sinai and Rabbi Leipziger of Touro Synagogue led prayer readings. This remained the congregational house of worship for 55 years, until residential movement forced a move to the suburb of Metairie in 1975.

Five

INTO THE 20TH CENTURY

The YMHA (Young Men's Hebrew Association) evolved after several attempts by young Jewish families to enter into an organization. Finally, on November 22, 1891, 300 gentlemen gathered at the Grunewald Hotel in response to a circular proposing the organization. The "home" of the organization, the Athenaeum, was dedicated November 18, 1896, at the corner of St. Charles Avenue and Clio Street. For many years, the meeting of the courts of Rex and Comus at midnight on Mardi Gras day, the official end of Carnival, took place in the Athenaeum's ballroom, even though Comus did not allow Jewish members. The Athenaeum burned down in 1937.

Pictured is the basketball team at the YMHA around 1920. Among the team members are M. Dresner, J. D. Dresner, Ricki Katz, Earl Hyman, and Messrs. Share and Goldberg. Many of New Orleans's great Jewish athletes got their start at the YMHA's gym.

The YMHA indoor championship softball team of 1910 is pictured. They are, from left to right, as follows: (sitting) C. Wenar, George Danziger (manager), Julius Michaelis (captain), and Stanford Blum; (standing) Charles Kahn, two unidentified men (one of whom may be C. Eiseman), A. D. Danziger (chairman of the athletic committee), Marion Weil, Moise Lichentag, Harry Weil, and Zac Adler.

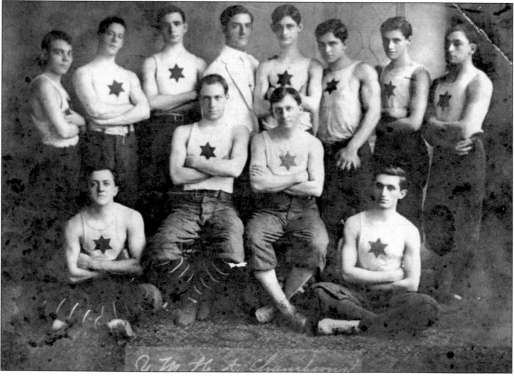

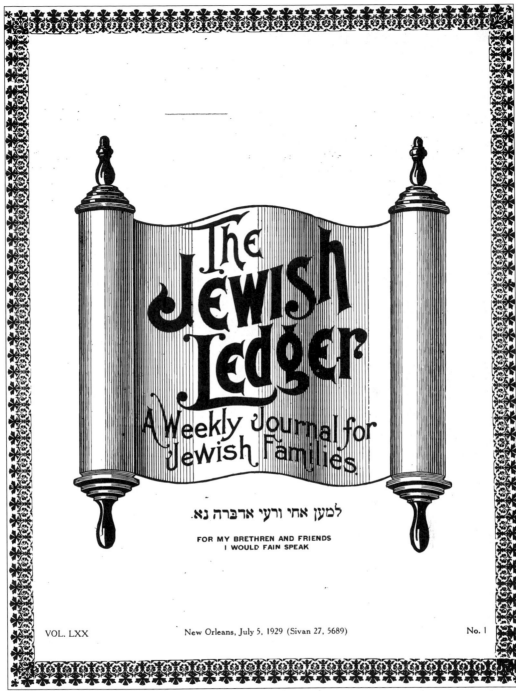

VOL. LXX New Orleans, July 5, 1929 (Sivan 27, 5689) No. 1

The Jewish Ledger, published by the Steeg family, covered the Jewish community of New Orleans and the mid-South, particularly the Reform community. Rabbi Max Heller of Temple Sinai was the first editor, but Rabbi Mendel Silber of Gates of Prayer served in that capacity for many years. The publication contained, besides Jewish news of New Orleans and other Southern cities, social, historical, and topical articles.

Isidore Newman School, now one of the most prestigious college preparatory schools in the New Orleans area, began as a manual-training school for the children in the Jewish Widows and Orphans Home. The suggestion for such a school came from Rabbi Isaac L. Leucht to the home board in 1889, which endorsed the idea, and in 1902, Isidore Newman offered to fund the building, which was constructed on Peters Avenue (now Jefferson Avenue) within walking distance of the home. The campus is now enlarged to include state-of-the-art classrooms, an elaborate gymnasium with swimming pool, and a football field. Its first major addition was the new lower school building, given by Percival Stern in 1947. During Newman's centennial celebration, a new lower school was dedicated, including a new Percival Stern Early Education Center.

"Manual" as it was then called, opened in 1903, and over the years, it attracted non-"Home Kids" because of its superior education. Here we see the kindergarten class (above) and the home economics classroom in 1905. In the 1930s, it dropped the "Manual" from its title, as its focus changed from vocational training to college preparation.

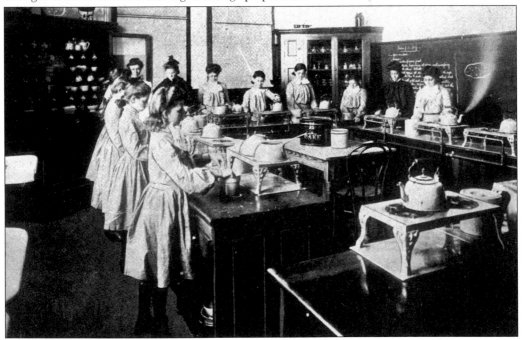

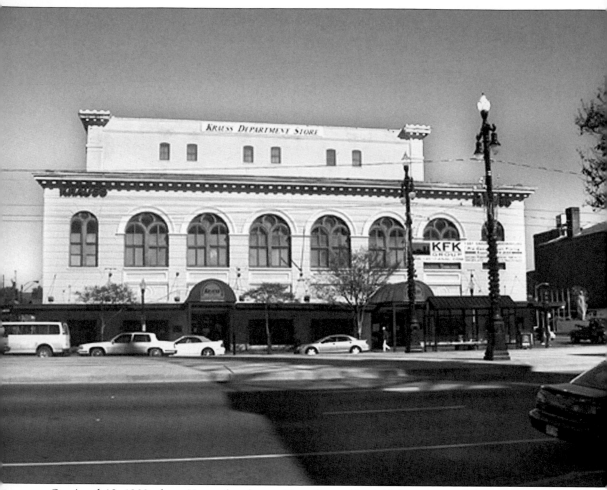

On April 13, 1903, three Krauss brothers—Sam, Leopold, and Max—opened Krauss Company on the corner of Canal and Basin Streets. Three years later, their sister, Thekla, married Leon Heymann, a retail merchant who owned stores in Houma, Thibodaux, New Iberia, and Morgan City, Louisiana. In 1922, Leon Heymann took over the presidency of Krauss Company in New Orleans. It continued to be a family business, which included his Krauss in-laws; his son, Jimmy Heymann; daughter, May; and son-in-law, Leon Wolf. Unlike the specialty stores owned by other Jewish merchants on Canal Street, Krauss carried a extensive inventory of clothing in large sizes, fabrics, furniture, appliances, and items found no where else. After Jimmy Heymann's death, his widow, Janice "Johnnie" Heymann, aided in running the civic and philanthropic activities at Krauss, while the business continued under the leadership of Hugo Kahn. It closed after almost a century of illustrious service to the community in 1997, and was one of the last single, family-owned stores in the country.

In 1905, pharmacist Gustave Katz (below), who had a drugstore in New Orleans, joined with Sydney Besthoff (above), who owned a drugstore in Memphis but had married a New Orleans lady, to form a partnership called Katz and Besthoff (K & B), which started with one drugstore on Canal Street. By the time Sydney Besthoff died in 1926, several more stores had been added. His son, S. J. Besthoff Jr., bought out the Katz family in 1940, retaining the now well-known name and signature color, "K & B purple." In 1962, management passed to Sydney Besthoff III. The chain of 186 stores was sold to Rite Aid in 1997.

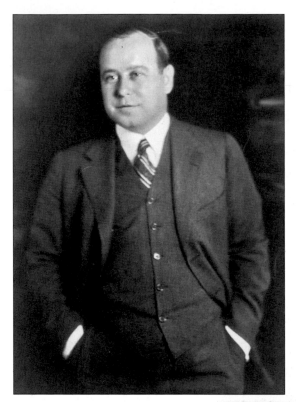

One of the South's preeminent architects, Emil Weil (1878–1945) was particularly active in Jewish religious buildings in the first quarter of the 20th century. In 1909, he won a design contest for the new Touro Synagogue on St. Charles Avenue. He designed both the new Beth Israel in 1924 and Anshe Sfard the following year. He also designed the entrance to Temple Sinai on St. Charles Avenue. Among his sectarian buildings were Saenger Theatres in New Orleans, Shreveport, Mobile, Pensacola, and Texarkana. He designed the Strand Theatre in Shreveport and the Tivoli Theatre in New Orleans.

Moise Goldstein (1882–1972) received his undergraduate degree from Tulane University and masters in engineering from the Massachusetts Institute of Technology. As one of New Orleans's premier architects, his firm designed the National American Bank Building, Sugar Bowl Stadium, Howard Tilton Memorial Library (now Jones Hall) on the Tulane campus, Moisant International Airport (now Armstong International Airport), and—perhaps his greatest achievement—the Dillard University campus. He also participated along with Weiss Dreyfous and Seiferth and Emile Weil in the design of Temple Sinai.

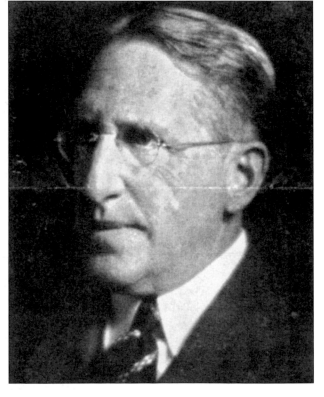

During the 1920s and 1930s, Weiss, Dreyfous and Seiferth was one of the most important architectural firms in Louisiana. Pictured above is Leon C. Weiss (1882–1953); below is Solis Seiferth (1895–1984). During the Depression, when patrons were scarce, their principal client was the State of Louisiana, whose governor, Huey Long, considered them his favorite architects. During that time, they built Charity Hospital, part of Louisiana State University, and they built the Louisiana State Capitol Building, their crowning achievement.

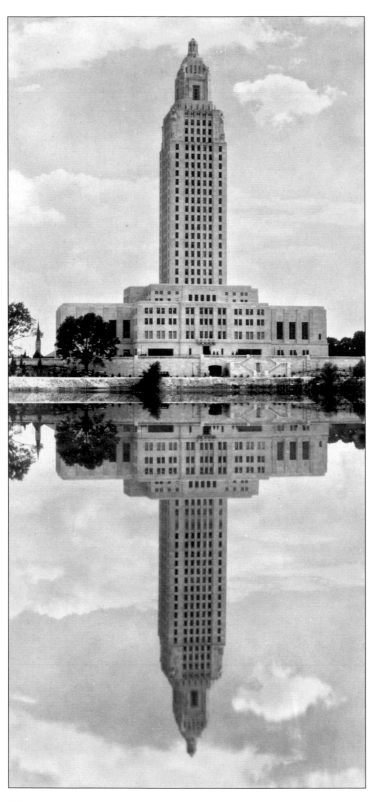

Shown here is the Louisiana State Capitol in Baton Rouge, Louisiana. The following is quoted from the architect Leon C. Weiss: "The capitol is a modern conception, exemplifying the highly developed civilization of the era of its creation. It is simple and restrained both in composition and detail, and though its component masses tend upward, in harmony with the towering masses, beyond the bounds of classical constraint, there is a conservatism—a harking back to tradition—to the end of avoiding the ultra-modernism that might well result in its being branded in future critical dictum as obsolescent, or decadent, in style."

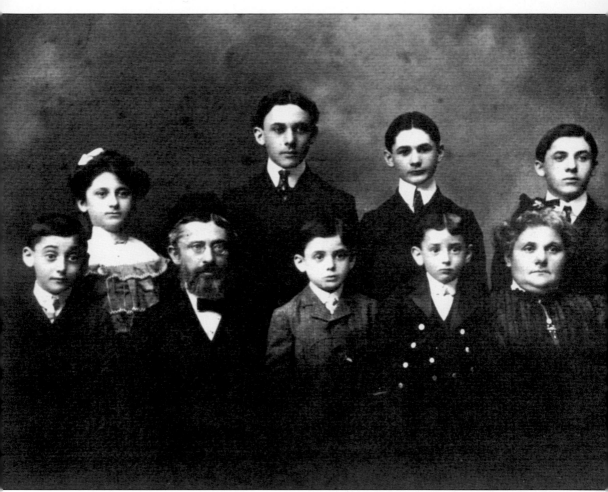

Joseph Goldman came from a little town on the Russian/Polish border about 1900. He came with his wife, Leah, and his oldest son Julius. The rest of his seven children were born in New Orleans. He joined the newly formed Orthodox synagogue, Beth Israel, serving as its gabbi, a learned layperson who guides the daily religious service. His "professions" were philanthropy and Judaism, according to his family, who all have commented that Joseph Goldman made sure that, even in this new world, they studied their religion. Julius Goldman became the director of the Community Chest and a member of the board of Touro Infirmary. Sam Goldman was the bookkeeper at Touro Infirmary. Joseph's only daughter Bessie married Touro physician A. L. Levin and founded a dynasty of Touro surgeons. Ben, Harry, and Henry were successful businessmen. Shown from left to right are as follows: (first row) Ben Goldman, Joseph Goldman, Harry Goldman, Henry Goldman, and Leah Goldman; (second row) Bessie Goldman, Julius Goldman, Sam Goldman, and Abe Goldman.

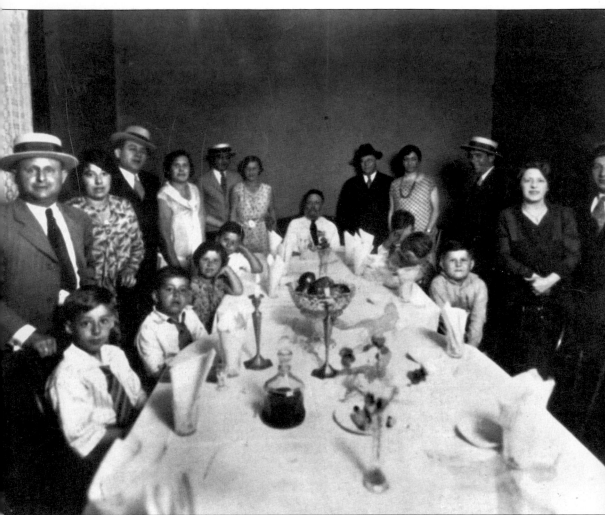

Hurwitz-Mintz Furniture Company was founded by Morris Mintz and his wife's brother-in-law, Joseph Hurwitz, in 1922. The business has grown into two stores, one in the French Quarter and another on Airline Highway in Metairie, Louisiana. Currently it is being managed by the third generation of the Mintz family. The picture here is of a Passover dinner in 1929, with members of the Mintz, Hurwitz, Goldblum, and Weisler families. Morris Mintz and his wife, Goldie, are third and fourth from left in the picture.

Expanding along Prytania Street, Touro Infirmary added buildings in 1925 spanning Aline Street. The buildings were connected in 1936 with an Art Deco addition by the architectural firm of Weiss, Dreyfous, and Seiferth. A bas-relief frieze over the doorway depicted science conquering superstition. The interior was lined with marble, and a bellboy waited to carry the patient's luggage to the room. This remained the hospital's main entrance until new buildings on Foucher Street greatly enlarged the campus in 1965.

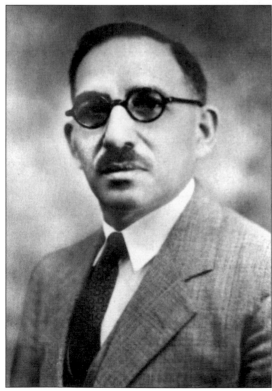

Doctor Abraham Louis Levin (1878–1942), inventor of the Levin Tube—which is still used for duodenal drainage after surgery—came to the United States from Poland in 1902. He graduated from Tulane University Medical School in 1907. He was appointed to the staff of Touro Infirmary in 1908, where he specialized in gastroenterology. It was during his service in World War I at Camp Beauregard in Louisiana that he developed the tube that bears his name. His, Irving, and grandson, Alan, have followed in his distinguished footsteps on the Touro Infirmary medical staff.

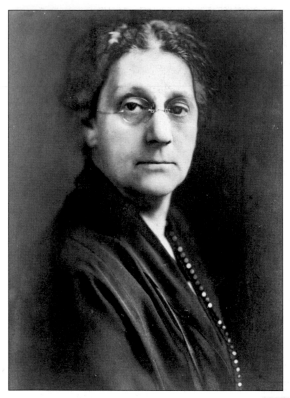

Ida Weis Friend (1868–1963), daughter of Julius and Caroline Weis, married Joseph Friend in 1890. Very active both politically and socially, Mrs. Friend served as president of the National Council of Jewish Women, New Orleans Women's Chapter of B'nai Brith, New Orleans Consumers League, and the Voters' Registration League, among others. She was a founder of the New Orleans Symphony Orchestra, the Lyceum Association, and the Spring Fiesta. She was a delegate to the Democratic National Convention in 1921 and a delegate to the Louisiana Constitutional Convention in 1921. Mrs. Friend was awarded the *Times Picayune* Loving Cup in 1946.

Montefiore Mordecai Lemann (1884–1959) grew up in Donaldsonville, Louisiana, and moved to New Orleans as a teenager, receiving his undergraduate degree from Tulane and his law degree from Harvard. In his long and distinguished practice, he argued cases before the United States Supreme Court and served President Herbert Hoover on the Wickersham Commission on Law Observance and Enforcement. During World War I, he was assistant chief counsel of the United States Shipping Board in Washington, D.C. Among his many honors was his selection as president of both the New Orleans Bar Association and the Louisiana State Bar. He kept his interest in Tulane University, teaching law, helping found Tulane Law Review, and serving as president of its advisory board and as president of the Tulane board of visitors. In the words of Justice Felix Frankfurter, "his scholarly bent enabled him to be an effective force in the life of the two universities of his allegiance, Tulane and Harvard."

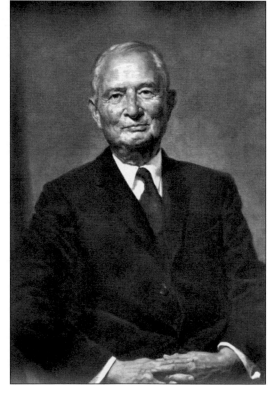

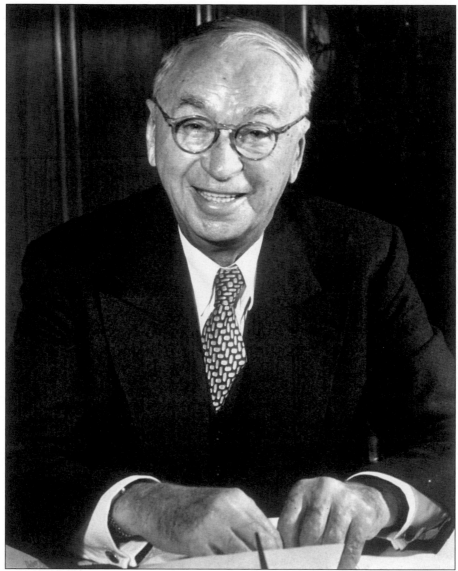

Samuel Zemurray (1877–1961) was born in Bessarabia. He moved to the United States and began selling bananas on the streets of Mobile. He expanded his business, forming the Cuyamel Fruit Company in New Orleans, and then purchased 5,000 acres of land in Honduras to grow his bananas. Zemurray felt that the custom tax agreement between the United State and Honduras was unfair, so he organized a coup, sending two mercenaries along with the former president of Honduras to engage in revolution. With little difficulty, the coup succeeded, and President Bonilla did not forget his friend Sam. For decades Cuyamel competed with the larger United Fruit Company. After a fierce price war, United Fruit decided to purchase Cuyamel from Zemurray for 300,000 shares of stock, making Zemurray the largest stockholder in the company. When the company floundered during the Depression, Zemurray, proxies in hand, stormed into the board of directors meeting and announced he was taking over. He was named managing director and, later, president of the company. In 1948, when the partition of Palestine came before the United Nations, Zemurray used his influence in Central America to get several of those countries to vote in favor of the partition. "Sam, the Banana Man" retired in 1951.

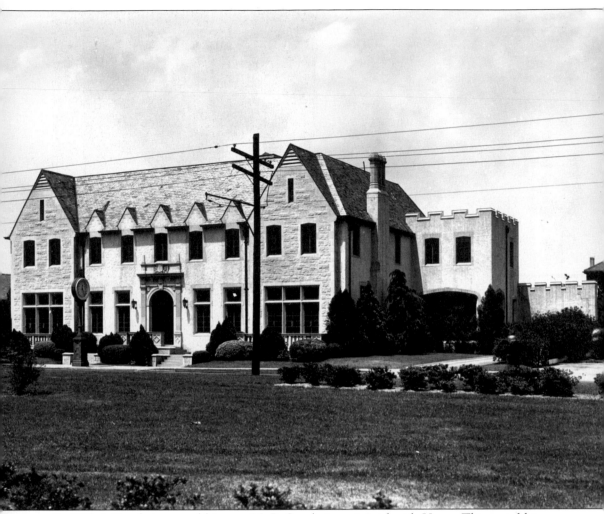

In 1916, I. Sontheimer and his son, M. B. Sontheimer, joined with Henry Tharp and his son, Alfred S. Tharp, to form Tharp Sontheimer Tharp Funeral Home on Carondelet and Toledano Streets. Their aim was to make their new establishment the best and largest in the South. A grand new building was constructed in 1931 on South Claiborne Avenue near Milan Street (pictured), with new generations of Tharps and Sontheimers running the business. Maurice and Jack Sontheimer were joined in the business by son, Stephen, and son-in-law, Leonard Wolff, as the company expanded to include Delta Life Insurance and five other funeral homes around the New Orleans area. In 1882, the entire holdings were sold to E. J. Ourso of Donaldsonville, Louisiana, at which time Stephen Sontheimer became chairman of Security Industrial Funeral Home Corporation. In 1991, Security purchased Bultman, a family-owned funeral home on St. Charles and Louisiana Avenues. The present owner is Loewen-Group of Vancouver, Canada.

Wemco, originally known in New Orleans as Wembley Tie Company, was founded by brothers Samuel (1905–1989), at right, and Emanuel Pulitzer (1902–1967), below. When the brothers were small, their mother had to place them in the Jewish Children's Home. As is true of so many "home kids," the Pulitzers became overachievers. By 1937, they had incorporated their company into Wembley, which ultimately became the largest men's tie manufacturer in the world, home of the Nor-East tie.

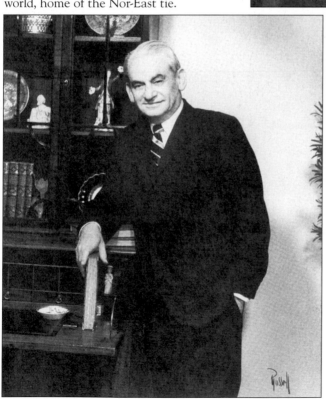

A native of Montreal, Canada, Malcolm Woldenberg (1896–1982), with his friend Stephen Goldring, founded Magnolia Marketing Company in New Orleans in 1944. They became a leading distributor of beer, wine, and liquor. Malcolm Woldenberg dedicated his later years to philanthropy, and the Dorothy and Malcolm Woldenberg Foundation has made major contributions to Touro Infirmary, the Jewish Children's Regional Service, Lakeshore Hebrew Day School, Tulane University, and Children's Hospital. The foundation has also supported causes in Israel, among them cultural and day care centers, and the Dorothy and Malcolm Woldenberg Orthopedic Hospital and Rehabilitation Center.

A native of Pensacola, Florida, where he began a wholesale alcohol distributorship soon after the repeal of Prohibition, Stephen Goldring (1908–1996) moved to New Orleans to open Magnolia Marketing with his friend Malcolm Woldenberg. Like Woldenberg, Goldring devoted his later years to directing his charitable Goldring Foundation, as well as the Woldenberg Foundation. Tulane University, University of New Orleans, the Jewish Federation, Temple Sinai, Henry Jacobs Camp, and Touro Infirmary (which honored him with the first Judah Touro Award) all benefited by his philanthropy. Pictured are three generations of Goldrings: Stephen, William, and young Jeff, who carries on the family traditions.

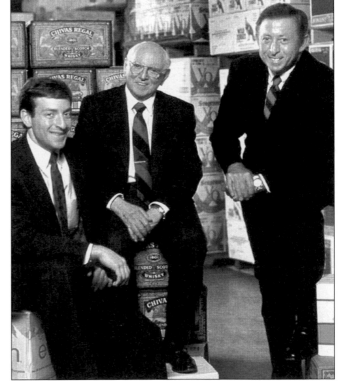

A native of Bayou Sara, Louisiana, Charles Rosen (1872–1957) came to New Orleans in 1887 to enroll in Tulane High School. While there, he was awarded the Judah Touro medal for his paper on history. How prophetic, since he served on the board of Touro Infirmary for 56 years, serving as chairman from 1926 to 1942. Upon graduation from Tulane Law School in 1894, Rosen entered private practice, and also took an interest in New Orleans politics, acting as spokesman for reform political candidates. One of his most notable battles was a successful campaign against Mayor Martin Behrman over control of the Public Belt Rail Road, which Behrman had tried to remove from the Public Service Commission. His service to Touro Infirmary is matched only by his term on Tulane University's board of administrators, lasting from 1904 to 1954, the last four years as chairman.

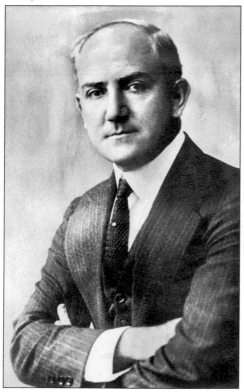

The grandson of Abel Dreyfous, Alfred David Danziger (1884–1948) naturally gravitated to the practice of law. A graduate of the Tulane University law class of 1904, he began practice in the law offices of his uncle, Felix J. Dreyfous. He served as assistant attorney general of the state of Louisiana in 1934 and executive counsel for Mayor Robert Maestri from 1936 to 1946. He was president of the Young Men's Business Club and the New Orleans Association of Commerce, and active in flood-control legislation and the development of Grand Isle. He was also prominent in the YMHA, where he managed the indoor baseball team, the Jerusalem Temple, and Masonic affairs. His name lives on, as the Danziger Bridge, named as a tribute to his civic endeavors, is in the news nearly every night as the site of a traffic snarl.

Henry Stern's (1896–1993) Antique Shop on Royal Street was well known far beyond New Orleans. But he was so much more than a dealer in fine antiques. He taught generations of New Orleanians how to recognize and appreciate his beloved French Provincial and Country, or Manor House English, furniture. His wife, Janice, became an expert on period fabrics, which added a decorative dimension to the antique shop. A graduate of Tulane University, he was a sponsor and actor at Le Petit Theatre, a member of the Royal Street Guild, and a member of the board of directors of the New Orleans Museum of Art. After Henry Stern's death, the shop continued for a few years, but without his incomparable spirit, it finally closed after 75 years.

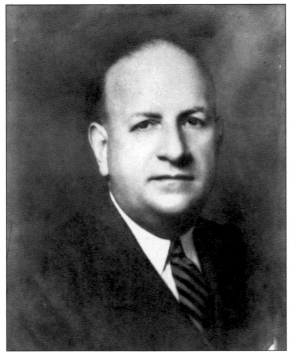

In 1909, Joseph Haspel and his brothers began making seersucker suits in their factory in New Orleans. Seersucker was a lightweight, inexpensive material, which looked the same no matter the heat and humidity. Before this innovation, New Orleans businessmen had the option of heavy wool or white linen suits in summer, which had to be laundered, starched, and ironed with every wearing. These suits gained popularity, not only with local gentlemen, but also with people around the country, including presidents and movie stars.

Six

20TH-CENTURY CLERGY

A native of Stockholm, Sweden, Rabbi Emil W. Leipziger (1877–1963) was a graduate of the University of Cincinnati and Hebrew Union College. Before coming to Touro Synagogue in New Orleans, he served at a congregation in Terre Haute, Indiana. He served Touro Synagogue for 34 years, and was known for his contributions to Jewish and community life, particularly in the fields of social service and philanthropy. He was one of the founders of the Community Chest of New Orleans (he presiding over the first meeting in 1924), for which he was awarded the *Times-Picayune* Loving Cup in 1925.

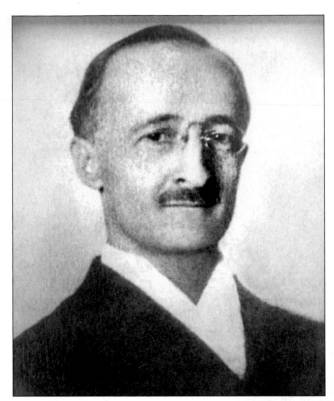

Congregation Gates of Prayer was founded in 1850 in Lafayette City, then a suburb of New Orleans. Its first rabbi was Maurice Eisenberg, who served from 1885 to 1892, followed by Rabbi Morris Sessler, who served from 1892 to 1904. These early rabbis were followed by Moise Bergman (1887–1948), pictured at left, a graduate of Hebrew Union College and a native of Louisiana. Under his leadership, Gates of Prayer joined the Union of American Hebrew Congregations in 1908. When Rabbi Bergman's wife became ill in 1913, he moved with her to Albuquerque, New Mexico, swapping pulpits with Rabbi Mendel Silber.

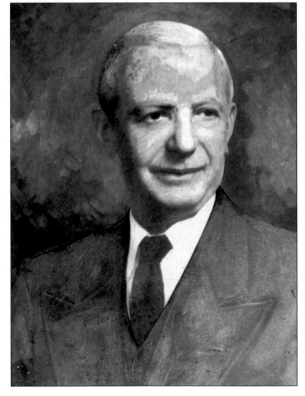

A native of Lithuania, Rabbi Mendel Silber (1882–1970) attended Hebrew Union College and was ordained in 1904. He was also a medical doctor, serving as acting dean and professor of psychology at the University of New Mexico. He came to Gates of Prayer congregation in New Orleans in a "rabbi swap" with Moise Bergman. Under Rabbi Silber's leadership, Gates of Prayer continued is gradual transformation from traditional Orthodox Judaism to the Reform Movement. Gates of Prayer also moved from the Jackson Avenue synagogue to the Napoleon Avenue synagogue, which was dedicated in 1920. Rabbi Silber was one of the editors of *The Jewish Ledger* and author of *Palestine, the Holy Land* (1927) and *America in Hebrew Literature* (1928).

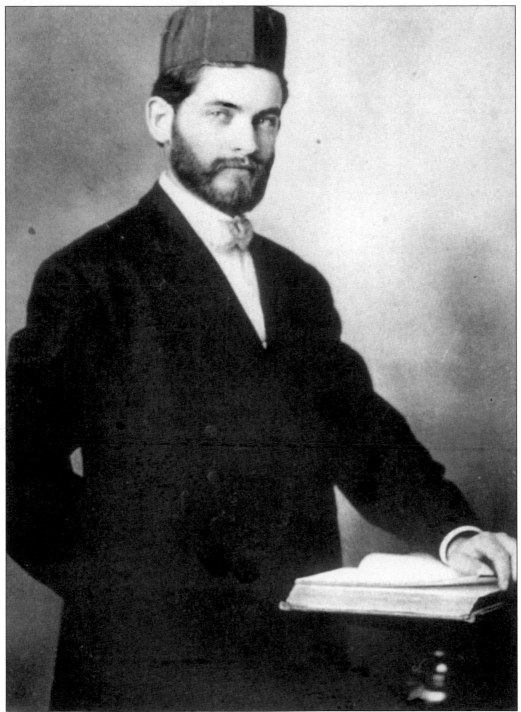

Rabbi Moses Hyman Goldberg (1885–1940) came to New Orleans in 1909 to serve as rabbi at Beth Israel, but left within a year and became rabbi at Chevra Thillum. He served the Orthodox community for over 30 years as its spiritual leader and, just as importantly, the local *mohel*, who did ritual circumcision.

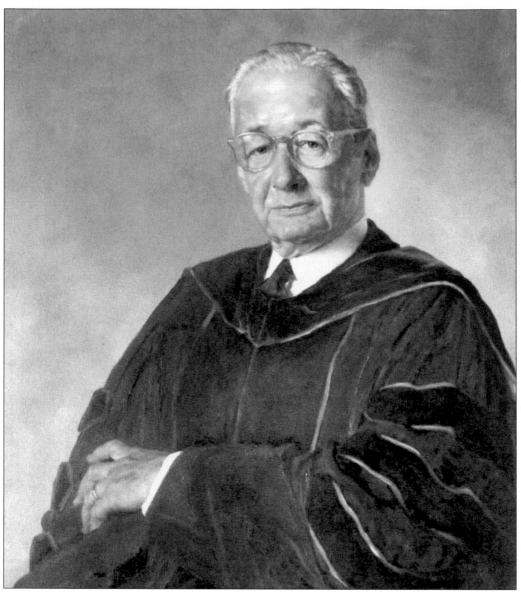

Rabbi of Temple Sinai for 30 years, Julian B. Feibelman (1897–1890) was a courageous community leader though the difficult years of the Great Depression, World War II, and the civil rights movement. He, with the approval of the temple board, invited United Nations delegate Ralph Bunche to speak at Temple Sinai to the first integrated audience in New Orleans. In the words of then mayor Ernest "Dutch" Morial, "He was a clear and forceful voice for human concerns and human rights long before these became popular movements." A truly ecumenical man, Rabbi Feibelman established close relationships with other clergy of all religions. His innovative "Operation Understanding," involving visits between congregations of Christians and Jews, continues to this day.

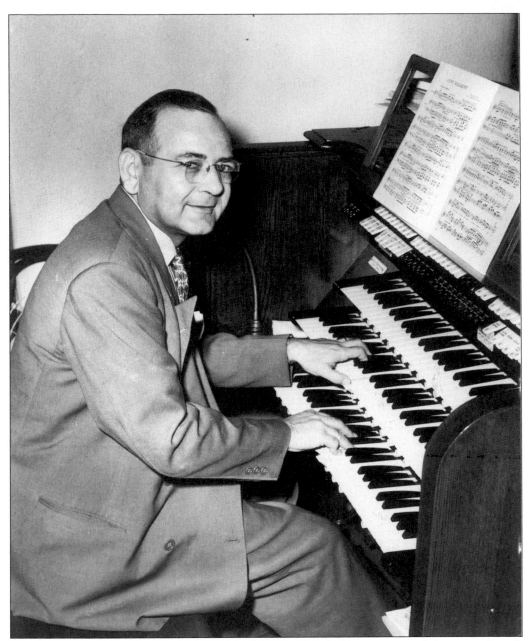

Camp Henry Jacobs is a household word in the Deep South, but not many of the young Jewish children and teens who enjoy the camp know much about the man for whom it was named. Henry S. Jacobs (1907–1965) was a musician, first and foremost. He was trained by Pietro Yon, organist emeritus of the Vatican, and he played in many churches here in New Orleans before becoming organist and executive director of Temple Sinai. He was an associate of the American Guild of Organists. He served in the Navy in World War II. Henry Jacobs's dream was to create a camp to fill in the gap for Southern Jewish youth between confirmation and adulthood. A site was found in rural Mississippi, and the camp developed into a living memorial to his vision.

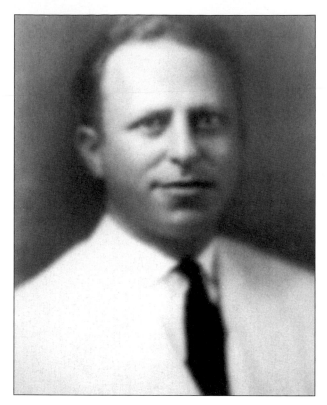

Rabbi Louis Binstock (1896–1976) was born in Hungary, came to the United States as a child, and grew up in Memphis, Tennessee. After receiving degrees from the University of Tennessee and the University of Cincinnati, he completed his studies at Hebrew Union College and was ordained a rabbi. Before coming to New Orleans in 1927, he served congregations in Baltimore and Charleston, West Virginia. While he was serving at Temple Sinai, the congregation moved into its new home on St. Charles Avenue. Rabbi Binstock was known as a spellbinding speaker who lectured on books, plays, pictures, and his travels, as well as religion, and filled the temple on Friday nights. After 10 years at Temple Sinai, he left for a pulpit at Temple Shalom in Chicago, which he held for 38 years.

A native of Cleveland, Ohio, Rabbi Leo A. Bergman (1913–1981) graduated from Case Western Reserve and Hebrew Union College. Before coming to Touro Synagogue in New Orleans, he served congregations in Boston and Rockford, Illinois. Rabbi Bergman was known for his outspokenness at a time of great turmoil in the South. Not only was the civil rights movement dividing neighbors, but also the controversy over whether there should be a Jewish state raised tempers in many congregations. Although it was not popular with his congregation in general, Rabbi Bergman supported the State of Israel's right to exist.

Rabbi Nathaniel Share (1908–1974) was the leader of Gates of Prayer Congregation for 40 years. Born in Montreal, Canada, he graduated from Hebrew Union College and was ordained in 1932. Before coming to New Orleans, he served two congregations in West Virginia. His first impact on Gates of Prayer was a reorganization of the religious school. He led his congregation through the difficult years of Depression, World War II, and the controversial civil rights movement, and through the happy events of their centennial in 1950. His courage, even in the face of criticism from his own congregation, impressed the community, and his death was greatly mourned.

Rabbi Murray Blackman (1920–2001) served as Temple Sinai's senior rabbi from 1970 until 1987, when he became rabbi emeritus. His interest in art, especially Jewish art, led to his becoming a master docent at the New Orleans Museum of Art and lecturer on European, Israeli, and American-Jewish artists. After his retirement, he served as interim rabbi worldwide, including such places as New Zealand, Honolulu, Curacao, the *Queen Elisabeth II*, Vicksburg, Mississippi, and Shreveport, Louisiana.

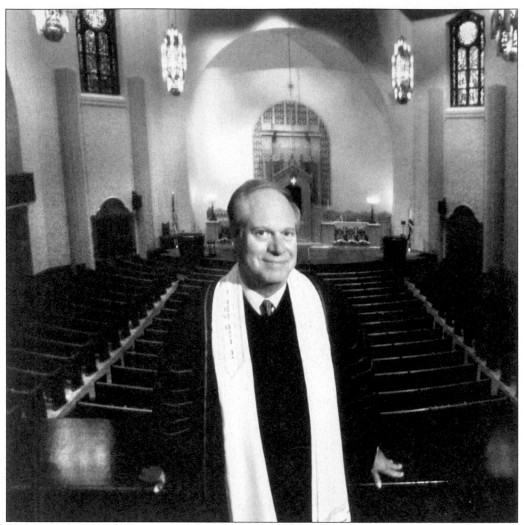

Before coming to Temple Sinai as their senior rabbi in 1987, Edward Paul Cohn (b. 1948) occupied pulpits in Atlanta, Georgia; Macon, Georgia; Kansas City, Missouri; and Pittsburgh, Pennsylvania. Following in the tradition of Rabbi Feibelman, Rabbi Cohn revived Operation Understanding in 2004. Rabbi Cohn has served as the chair of the New Orleans Holocaust Memorial Project, which installed a sculpture by Agam on the riverfront in Woldenberg Park. He is founding chairman of the Human Relations Committee of New Orleans. He serves on many committees both local and national, and teaches at both Dillard University and Notre Dame Seminary. In his honor, members of his congregation have had the magnificent organ in the sanctuary restored, knowing his passion for organ music.

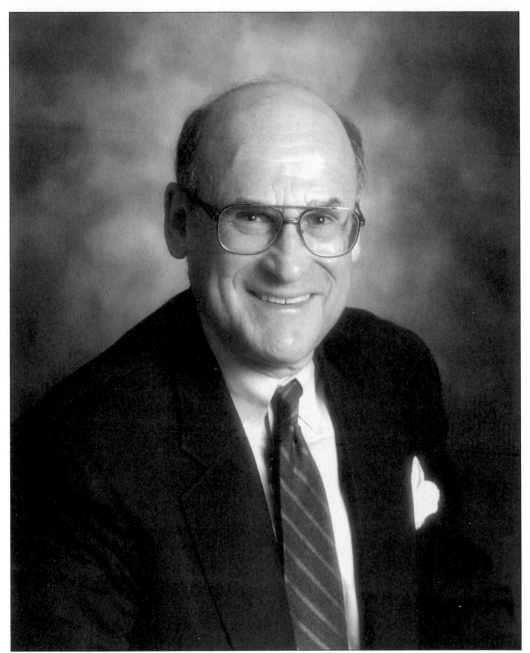

Rabbi David Goldstein (b. 1937) was born in Princeton, New Jersey, and is a graduate of Miami University of Ohio and Hebrew Union College. He was ordained in 1965, after which he served as a chaplain in the United States Navy, retiring with the rank of captain. Before coming to Touro Synagogue in 1978, he served as associate rabbi of Baltimore Hebrew Congregation. Rabbi Goldstein serves on the faculty of Tulane University as adjunct professor of Jewish studies and is published in many scholarly journals. In 1981, 1983, and 1986, he and his wife traveled to the Soviet Union, where they visited with hundreds of Jewish "Refuseniks" and helped to organize secret classes in Jewish studies and music. In 1999, he was the recipient of the Weiss Award from the National Conference of Christians and Jews.

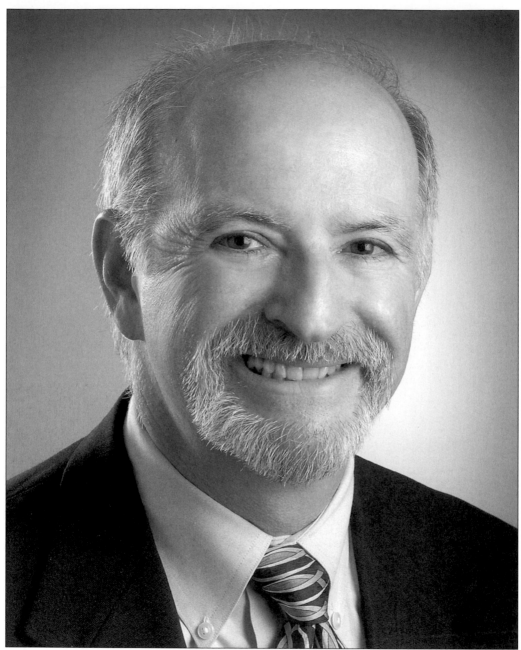

Rabbi Robert H. Loewy (b. 1950) is the ninth rabbi to occupy the pulpit at Congregation Gates of Prayer. A native of Hempstead, New York, he is a graduate of Cornell and Hebrew Union College, and was ordained in 1977. He became rabbi of Gates of Prayer in 1984. Among his many leadership roles in New Orleans were the chairmanship of the community relations committee of the Jewish Federation and presidency of the Jewish Day School and the Southwest Association of Reform Rabbis. Rabbi Loewy is a Jewish Chautauqua Society lecturer at Loyola University, and served on the steering committee for the Dillard University Center for Black/Jewish Relations.

Seven

MID-CENTURY NEW ORLEANS JUDAISM

The daughter of Felix Dreyfous, Ruth Dreyfous (1901–1998) grew up in the lap of luxury, but became a tireless fighter for causes she believed in. She graduated from Newcomb College and received a master's degree from Columbia University. She worked mostly pro bono for Newman School as a guidance counselor, did educational testing for Kingsley House, and, in the 1960s, was part of a group of courageous women who braved the segregationists in Plaquemines Parish to keep the public schools open. She was awarded the Ben Smith Award by the American Civil Liberties Union, its highest honor, in 1985.

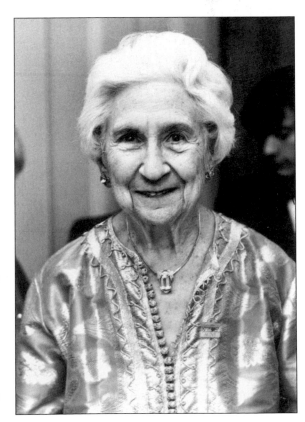

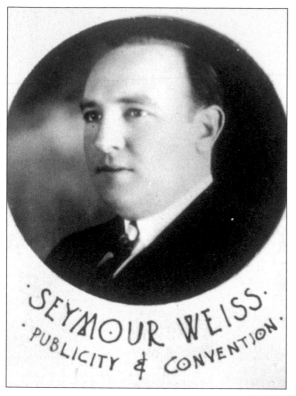

SEYMOUR WEISS
PUBLICITY & CONVENTION

Born in Bunkie, Louisiana, Seymour Weiss (1896–1969) moved to New Orleans in 1916, where he worked as a clerk in a shoe store. In 1923, he became manager of the barbershop at the Roosevelt Hotel, assistant manager of the hotel the following year, manager in 1928, and principal owner and managing director in 1931. Huey Long was a regular guest of the hotel, and Weiss became Long's closest confidante. Weiss had personal control of the "deduct box," money deducted from the checks of state employees and turned into cash for Long to use in his various political operations. During the "Louisiana scandals" Weiss was found guilty of mail fraud and tax evasion and served 16 months in jail. After his parole he once again became a leader in civic organizations as director of the New Orleans chapter of the American Red Cross, director of the New Orleans Chamber of Commerce, and director of International House and the International Trade Mart.

Abraham Lazar Shushan (1894–1966) and his brother, George, operated Shushan Brothers Toys. In 1920, Abe was appointed by Gov. John Parker to the Orleans Levee Board and was reappointed by Huey Long in 1928. Shushan became president of the board in 1929. As president he spearheaded the erection of the seawall to protect low-lying New Orleans from flooding. At the urging of Long, Shushan also built the Shushan Airport—in which he put his name on everything that did not move (including the faucets in the bathrooms)—on a landfill granted him by the Levee Board.

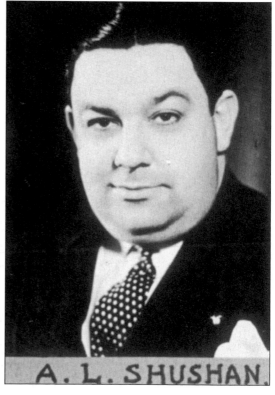

A. L. SHUSHAN.

In 1898, Jacob Aron (1871–1961) formed a partnership with his brother-in-law, Leon Israel (1871–1957), to import coffee. After the partnership dissolved, J. Aron and Company continued in business. In 1905, Aron moved to establish a New York branch, and William B. Burkenroad, a partner in the business, managed the New Orleans company, located on Magazine Street. In the next generation, Jack Aron (1910–1994) headed the New York operation, and William B. Burkenroad Jr. (1903–1995) took command of the New Orleans branch. In 1978, J. Aron and Company ceased to import coffee, but continued to trade in commodities. These families have given back so much to the community, including to Tulane University, Touro Infirmary, the New Orleans Museum of Art, and many other institutions. Pictured is Jack Aron.

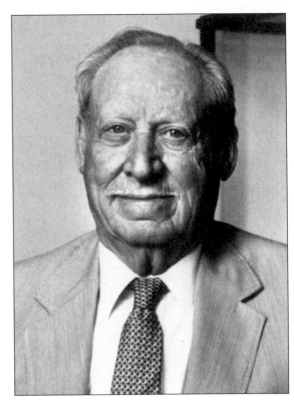

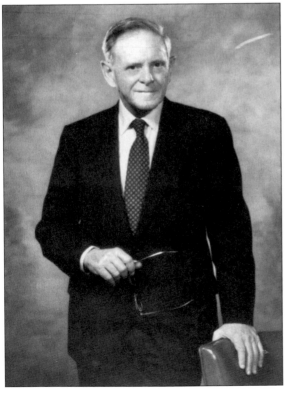

After coming to New Orleans from Clinton, Louisiana, where the family was in the grocery business, Leon Israel, with his brother-in-law, Jacob Aron, founded Leon Israel and Brothers in 1898. When this partnership dissolved, Leon Israel and Company continued importing green coffee, with a New York and a New Orleans branch, and Adrian C. Israel, called "Ace," formed another related company. In 1970, the next generation of Israel cousins got together to form ACLI International, combining the A. C. Israel and the Sam Israel Jr. and the Leon Israel Jr. branches into one umbrella corporation, with offices in New Orleans, New York, and San Francisco. In 1980, the company was sold to Donaldson, Lufkin, and Jenerette Co. Pictured is Sam Israel Jr.

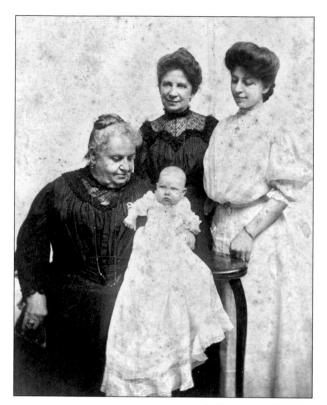

Illustrating the tradition of New Orleans Jews, who tend to stay in the Crescent City all their lives if possible, are two pictures of the same family taken 24 years apart. In this 1906 picture, great-grandmother Caroline Kaufman Dreyfous, wife of Able Dreyfous, poses with her daughter, Amelie Dreyfous Danziger, widow of Civil War soldier Isidore Danziger. Her daughter is Jennie Danziger Jacobson, wife of Meridian, Mississippi, native Isidore Jacobson, and mother of the baby.

In this 1930 photograph, the great-grandmother is now 80-year-old Amelie Dreyfous Danziger (mother of Alfred Danziger, sister of Felix Dreyfous). The grandmother is Jennie Danziger Jacobson, and the chic young mother is Bertha Jacobson Cahn, now wife of Leon Solis Cahn, a New Orleans attorney, who himself is the grandson of Leon Cahn, who is pictured with the Temple Sinai choir. The chubby-cheeked baby is Catherine Joan Cahn, who is coauthor of this book and who grew up to marry Fred Kahn II. These two pictures show five generations of New Orleans Jewish women.

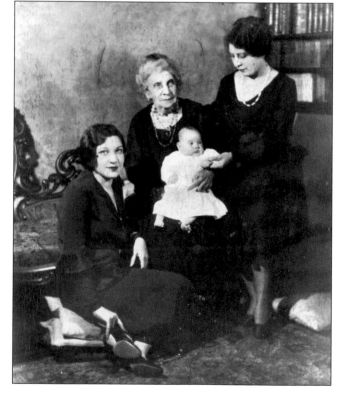

Gladys Cahn (1901–1964) was born in Chicago and married Moise Cahn of New Orleans in 1922. She served locally as president of the New Orleans Urban League, the Louisiana Conference on Social Welfare, and the Louisiana Organization for State Legislation, and as secretary of the Louisiana Advisory Committee of the United States Civil Rights Commission and a member of Save Our Schools. Mrs. Cahn also served as president of both the National Council of Jewish Women and the International Council of Jewish Women.

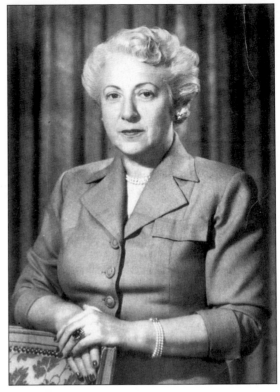

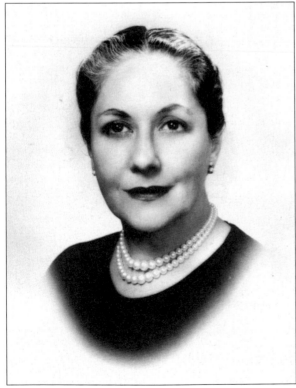

Rosalie Palter Cohen (b. 1910) grew up in the closely-knit Orthodox community of the Dryades Street neighborhood. Under the tutelage of Ephraim Litzitsky, she became a Hebrew scholar and star pupil of the Communal Hebrew School at a time when this was rare for women. At Tulane University, she was a journalism and English major; after graduation she became a leader in such organizations as Hadassah and Jewish Federation. In 1959, she became the first woman to be elected president of Jewish Federation, which she led with outstanding competence. Her most lasting contribution to the Jewish community of New Orleans is the founding of Willow Wood, Home for the Jewish Aged, in 1959, which is now Woldenberg Village Retirement Community, a part of Touro Infirmary.

Ida Rittenberg Kohlmeyer (1912–1997) was 37 years old before she began to pursue a career as an artist. She had earned her undergraduate degree in English literature from Newcomb College. She returned to her alma mater to earn a master's degree in art. She studied with Hans Hoffman, changing her focus from representative art to abstract expressionism. She was a member of the Orleans Gallery, a pioneering cooperative in New Orleans. Her paintings and sculpture have been exhibited worldwide.

A native of New Orleans and graduate of Tulane University, Lucile Jacoby Blum (b. 1904) has devoted her adult life to promoting the performing arts. She led in the founding of the Louisiana Council of Music and the Performing Arts and the Louisiana State Arts Council. Among the many honors she has received, an honorary degree of doctor of humane letters was conferred upon her by Louisiana State University. She was awarded the *Times Picayune* Loving Cup in 1969 for contributions to the community for the benefit of fellow citizens and for efforts to improve the civic, cultural, and educational aspects of the city of New Orleans. Her love of music is such that even at 101 years of age, she can be found enjoying the opera in her usual box.

Sydney Johnson Besthoff III (b. 1927) was heir to a local chain of 15 drugstores. When he retired in 1997, the chain had become an enterprise of 186 stores in six states. He then focused his attention on his avocation, his collection of modern art. In the 1970s, he donated the former K & B warehouse building to the Contemporary Art Center. His sculpture collection filled the terrace of K & B Plaza, his current headquarters. In November 2003, the Sydney and Walda Besthoff Sculpture Garden opened at the New Orleans Museum of Art, a magnificent gift to the people of this city.

Pictured at left is a sculpture by Ida Kohlmeyer in the Besthoff Sculpture Garden.

Dr. Arthur Silverman (b. 1923) is a 1947 graduate of the Tulane University Medical School, and he practiced urology for more than 30 years in New Orleans. He began making metal sculpture as a hobby, and after retiring from medical practice, he devoted his attention to his art. His work is included in public and private collections throughout the United States. His sculpture is based on the tetrahedron, a three-dimensional form defined by the fewest possible flat surfaces. His outdoor sculptures can be seen around New Orleans in front of many public buildings. The photograph of Dr. Silverman is by Herman Leonard.

This imposing mansion, the Zemurray House—located at Audubon Place and St. Charles Avenue—was built in 1908 for cotton merchant William T. Jay. The architects were the well-known firm of Toledano and Wogan. In 1917, the house was sold to Samuel Zemurray, who ordered extensive renovations. After his death in 1965, Zemurray's widow, Sarah, donated the house to Tulane University to serve as the president's residence.

Joseph Rittenberg, originally from Bialystock, settled in New Orleans in the early 1890s. He opened a pawn shop, which he named Uncle Joe's Loans, on the corner of South Rampart and Gravier Streets. Eventually he went into real-estate loans and changed the name to Security Loans. He moved to this home on the corner of St. Charles Avenue and Rosa Park. Both of his sons, Leon and Charles, graduated from Harvard Law School, and his daughters, Ida Kohlmeyer and Mildred Wohl, were artists of renown. Incidentally, Rosa Park was named for Rosa Solomon Da Ponti by her husband, Durant Da Ponti, publisher of the *New Orleans Delta* newspaper and grandson of Lorenzo Da Ponti, Mozart's librettist. Rosa was the sister of Clara Solomon, noted Civil War diarist.

This charming Creole cottage was built in 1846 by Black freeman Henry Jacobs. In 1856, Judah P. Benjamin and his brother, Joseph, bought the house for their widowed sister, Rebecca Benjamin Levy (called Penny). Though the address of the house is now on Arabella Street, it originally faced St. Charles Avenue. Federal troops seized the house on August 20, 1863. In 1864, it was bought at tax sale by J. Madison Wells, lieutenant governor of Louisiana. It is owned today by the Edwin O. Schlesinger family.

Built by Favrot and Livaudais for Marks Isaacs in 1907, this large mansion covers a block on St. Charles Avenue. The next owner in 1912 was Frank Williams, whose son, Harry, with his wife, silent film star Marguerite Clark, lived and entertained in the house until Harry Williams's death in 1936. In 1947, the house was bought by Harry and Anna Latter and presented as a gift to New Orleans in memory of their son, Milton, who was killed in action on Okinawa in World War II.

Commissioned in 1939 by Edgar and Edith Stern, two of New Orleans's preeminent philanthropists, Longue Vue House and Gardens ably combines the marriage of architecture and landscape architecture. The house, of the Country Place era, was designed by architects William and Geoffrey Platt, and the landscaping was the masterwork of Ellen Biddle Shipman, the "dean of American women landscape architects." Longue Vue is registered as a National Historic Landmark and as an accredited museum. Both the house and garden are open to the public.

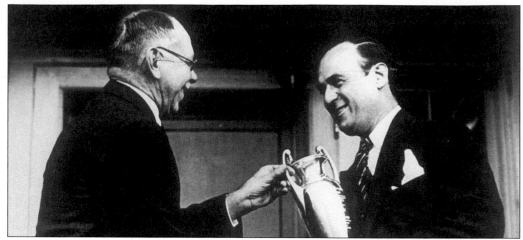

Edgar Stern (1886–1959) was named the outstanding New Orleans philanthropist of the century by the New Orleans *States-Item*. After graduating from Harvard in 1908, he returned home and entered the family business of Lehman, Stern, and Co., cotton merchants. Among his many civic enterprises, he served on both the Orleans Parish School board and the Charity Hospital board, and as director of the New Orleans branch of the Federal Reserve Bank. He was a trustee of the Tuskegee Institute, president of the board of trustees of Dillard University, and president of the board of trustees of the Flint-Goodridge Hospital. Stern served as president of the Community Chest, as trustee of the Howard-Tilton Memorial Library, as director of the Times-Picayune Publishing Co. and the Whitney Bank, and as a trustee of the Julius Rosenwald Fund. He established WDSU-TV in 1948. In 1930, he was awarded the *Times Picayune* Loving Cup, pictured here.

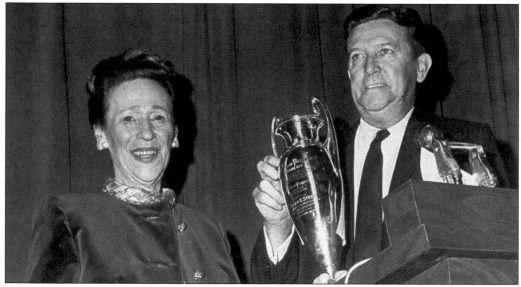

Edith Rosenwald Stern (1895–1980) was born in Chicago, the daughter of Julius Rosenwald, head of the Sears Corporation, and she married Edgar Stern in 1921. Mrs. Stern was a member of the Orleans Parkway and Park Commission and executive secretary of the New Orleans housing projects. She established the Newcomb Nursery School and the Metairie Park Country Day School. She was active in voter registration activities in the early 1950s. She and her husband established the Stern Fund, which contributed over $10 million to charitable causes. Mrs. Stern was awarded the *Times Picayune* Loving Cup in 1964.

Capt. Neville Levy (1892–1974) will forever be immortalized as the "father" of the Crescent City Connection, the bridge that connects New Orleans to the west bank of the Mississippi. He graduated from Tulane University with a degree in engineering in 1912. During World War I, he served in the Army Air Corps, and after the war went to Annapolis, where he studied submarines. In 1921, he opened Equitable Equipment, a shipbuilding company in New Orleans, and later acquired Higgins Shipbuilding plant as well. Among his many leadership roles in New Orleans was president of International House and chair of the Mississippi River Bridge Authority. He received the *Times Picayune* Loving Cup for his civic leadership.

Walter M. Barnett (1903–1996), a distinguished attorney, civic leader, and author of Louisiana's first adoption law, served as secretary and attorney for the Department of Public Welfare for the City of New Orleans and chairman of the Mayor's Advisory Committee under four administrations. He also served as president of many institutions, including United Fund, Family Service, Citizens' Housing Council, Touro Infirmary, Tulane Alumni Association, New Orleans Bar Association, and many more. He received the Judah Touro Society Award in 1993 from Touro Infirmary, the New Orleans Bar Association's President's Award, and Tulane University Law School's Distinguished Alumnus, among countless other recognitions. He was long associated with the firm of Montgomery, Barnett, Brown, Read, Hammond, and Mintz. His son-in-law, Albert Mintz, continues practice in the firm, and has followed in his footsteps by receiving the Judah Touro Society Award in 1999.

The main entrance to Touro Infirmary moved around the corner to Foucher Street in 1965, with the construction of the Hortense and Jacob Aron Building. Touro Infirmary remains in the same location in newer buildings, the oldest private not-for-profit hospital in Louisiana. It has served the Jewish community in the past as a haven for the elderly, as a charitable institution caring for the indigent sick, and as a community-wide medical center. It is a full-service hospital, still guided by the moral and ethical principles of Judaism.

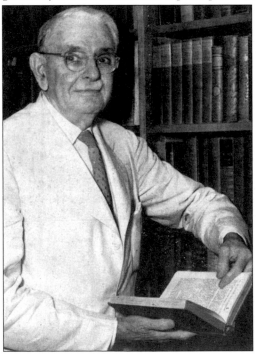

Following in the footsteps of his mentor, the legendary Dr. Rudolph Matas, Dr. Isidore Cohn Sr. (1885–1980) was named chief of the department of surgery at Touro Infirmary in 1935. Born in Cinclare, Louisiana, he graduated first from Louisiana State University with a degree in chemistry and then Tulane Medical School in 1907; the same year, he became an intern at Touro Infirmary, where he created a distinguished career for the next 48 years. He became nationally recognized as an authority on the surgical treatment of fractures and served as physician to the children in orphanages of three different religions. Dr. Cohn was also beloved as a teacher of medical students and nurses. A scholar as well, Dr. Cohn wrote many articles on medicine, religion, and history, and a biography of Dr. Matas. His son, Dr. Isidore Cohn Jr., has carried on the tradition, teaching generations of surgical students at Louisiana State University School of Medicine.

118

From 1951 to 1968, Dr. Sam Nadler (1905–1969) was the first director of the department of biophysics and nuclear medicine at Touro Infirmary. Born in Canada, Sam Nadler earned a degree in chemistry from Harvard. He came to Tulane University to teach biochemistry to medical students. He then studied medicine at Tulane, graduating in 1936 and affiliating with Touro Infirmary. After World War II ushered in the atomic era, he studied at the medical division of Oak Ridge Institute for Nuclear Studies, and brought his new knowledge to New Orleans to the biophysics program at Tulane and Touro Infirmary's research division.

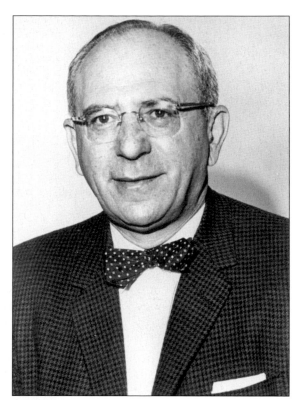

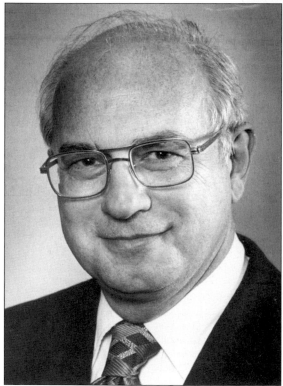

Dr. Ted Bloch (1923–1975) became the second director of the department of biophysics and nuclear medicine at Touro Infirmary in 1969. In addition, he was chairman of the department of medicine at Touro Infirmary and founder and director of the chronic hemodialysis unit, also at Touro Infirmary. After their deaths, the nuclear medicine department at Touro was renamed in honor of Dr. Nadler and Dr. Bloch, and a lecture in memory of Dr. Bloch is given annually by the southwestern chapter of the Society of Nuclear Medicine.

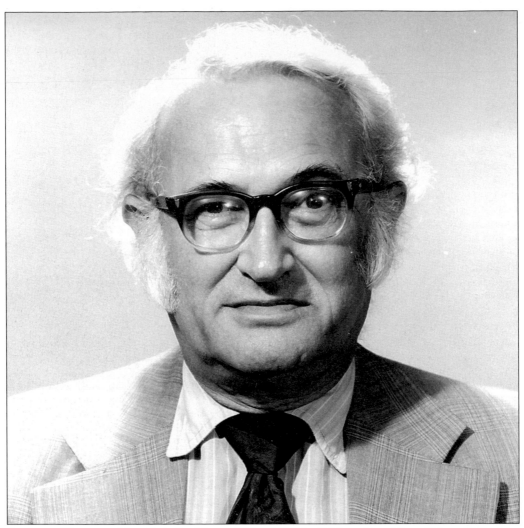

A native of Syracuse, New York, Dr. Morton Ziskind (1914–1978) graduated from Tulane University School of Medicine in 1942. During World War II, he was awarded the bronze star for medical services in the South Pacific. He served on Tulane's medical school faculty for 29 years, where he was renowned as a beloved teacher. He led the division of pulmonary medicine at Tulane to international stature as a center for training and research in diseases of the chest. He was the author of numerous scientific papers and books in his field.

From mid-19th century on, Jewish merchants prospered along New Orleans's widest, finest street. Godchaux (which continued for over 100 years), Gus Mayer, Mayer Israel, Imperial Shoe Store, Kreeger's, Goldring's, Maison Blanche, Hausmann's Jewelry Store, and Krauss all served New Orleans's most discriminating shoppers. Today, only Coleman Adler, a fine Jewelry store that recently acquired Waldhorn Antiques and Rubinstein Brothers, a men's retail store, remain in business.

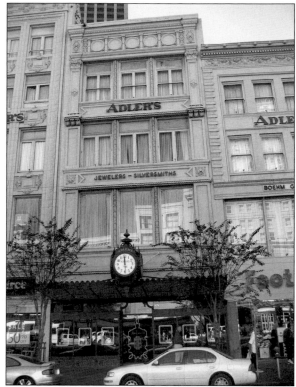

The family that owned Krauss Company is pictured on the occasion of the golden wedding anniversary of Leon Heymann and his wife, Thekla Krauss Heymann, who are seated in the center of the front row, with their grandson, Jerry Heymann. On the back row are Jimmy Heymann, Janice (Johnnie) Levy Heymann, Leon Wolff, and May Heymann Wolff.

Eight

Today's Jewish Community

In 1955, Congregation Chevra Thilim voted to allow mixed seating while remaining Orthodox. Those who opposed the mixed seating sued, and the Louisiana Supreme Court ruled in their favor. As a result, the Conservative Congregation of New Orleans was founded in 1960 on Napoleon Avenue. The congregation grew slowly until 1977, when they moved to the suburb of Metairie, where they have prospered. The year before the move, the congregation adopted the name Tikvat Shalom, or Hope of Peace. Meanwhile, Chevra Thilim eventually adopted mixed seating and joined the Conservative movement. But, being uptown, membership continued to lag. Then, in 1999, the two congregations joined together again, in Metairie, and adopted the name Shir Chadash, or New Song.

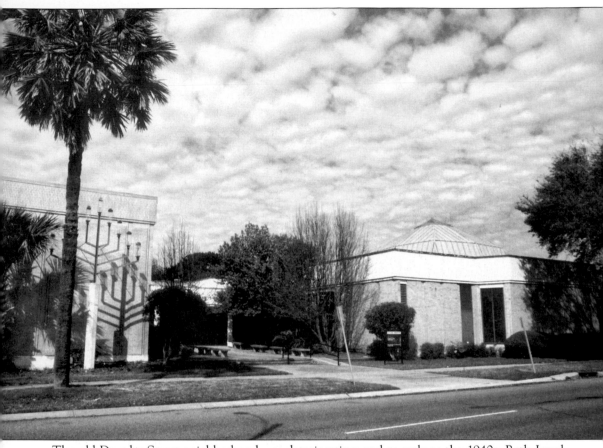

The old Dryades Street neighborhood was deteriorating, and as early as the 1940s, Beth Israel began looking for new locations. In 1963, the corner of Canal Boulevard and Walker Street was purchased, and in 1971, Beth Israel moved to the new location. Today Beth Israel is the only congregation in the city offering services twice daily.

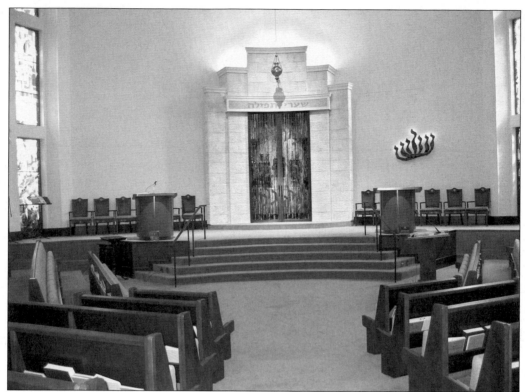

With the movement of many Jews to the suburb of Metairie, it was natural that the congregations would follow. The first to move was Gates of Prayer. On the weekend of September 5, 1975, the congregation celebrated the dedication of their new sanctuary, located at the intersection of West Esplanade Avenue and Richland Street. The charters of the other congregations provided that the congregations must be domiciled in Orleans Parish. Gates of Prayer, originally chartered in Lafayette City, then part of Jefferson Parish, had no such restriction in their constitution. These pictures reflect a recent renovation of the sanctuary.

Congregation Gates of Prayer Synagogue
West Esplanade Avenue • Metairie, Louisiana

In 1975, Rabbi Zelig Rivkin and his wife, Bluma, were sent to Louisiana as emissaries of the rebbe of Chabad-Lubavitch. Chabad House was then established near Tulane University. In 1990, the Chabad Center of Metairie was established, with Rabbi Yossie and Chanie Nemes as emissaries, to serve the growing Jewish community in the New Orleans suburb. Chabad of Louisiana also operates a Jewish day school, Torah Academy, with classes from pre-kindergarten through eighth grade.

The Jewish Children's Home was on this site until 1948, at which time the building became the Jewish Community Center. In the early 1960s, the old building was torn down and the new Jewish Community Center was built. Today the center provides numerous athletic and social activities as well as maintaining a vibrant preschool.

In 2001, a new Jewish community center was completed in Metairie to replace a smaller campus nearby. The new Metairie Jewish Community Center stands next door to Congregation Shir Chadash and across the street from Congregation Gates of Prayer. The expanded Metairie Jewish Community Center has quickly become a favorite gathering and activities location for the large proportion of Jews that live in the suburb.

An avid supporter of Israel, William Hess (b. 1947) has held leadership roles in the Association of Reform Zionists of America (ARZA), Union of American Hebrew Congregations, The Jewish Agency for Israel, the Zionist Organization of American (ZOA), and many others. He was selected as the ZOA man of the year in 1982, and received the Simon Wiesenthal Center Community Service Award in 2001. As a past president of Temple Sinai, the oldest Reform congregation in New Orleans and one in which classical reform origins are still to be felt, William Hess has been a persistent advocate toward reclaiming some traditional Jewish customs. The first president to wear *tallit* and *kippah* on Sinai's Bemah, to learn to chant Torah, and to lead mission after mission to Israel, Hess has been an ardent and determined advocate of the definition of Reform Judaism for the 21st century.